ABSTRACT EXPRESSIONISM
FOR BEGINNERS ®

ABSTRACT EXPRESSIONISM
FOR BEGINNERS®

BY
RICHARD KLIN

ILLUSTRATED BY
LILY PRINCE

FOREWORD BY
STEVEN ZUCKER

For Beginners®

For Beginners LLC
155 Main Street, Suite 211
Danbury, CT 06810 USA
www.forbeginnersbooks.com

A For Beginners® Documentary Comic Book
Copyright © 2016

Cataloging-in-Publication information is available from the Library of Congress.

ISBN-13 # 978-1-939994-62-2 Trade

Manufactured in the United States of America

For Beginners® and Beginners Documentary Comic Books® are published by For Beginners LLC.

First Edition

10 9 8 7 6 5 4 3 2 1

CONTENTS

This wouldn't have been a book without the support of Jeff Hacker and Merrilee Warholak at For Beginners. Additional thanks to: David Amram; Peter Balakian; Daniel Belasco, curator, the Samuel Dorsky Museum of Art at the State University of New York, New Paltz; Pamela Lawton; and Sara Rubenson of the Whitney Museum of American Art.

"To Arshile Gorky" used with kind permission of Peter Balakian.

"The East Village of the 1950s: An Island Within an Island" is from David Amram's forthcoming book, *David Amram: The Next 80 Years*, and is used here by his kind permission.

May Swenson's "At the Museum of Modern Art" © May Swenson. Used with permission of the Literary Estate of May Swenson. All rights reserved.

**Art in the blood
is liable to take
the strangest forms.**

—*Arthur Conan Doyle*

FOREWORD
by Steven Zucker

During the years immediately following the Second World War, a small group of New York painters reinvented American art and challenged the definition of modernism. This was an extraordinary moment by any measure. Atomic weapons had been created and unleashed on civilian populations, quickly bringing a Japanese surrender and an end to the global conflict. The unspeakable horrors of the Holocaust were confirmed, and the full extent of the Nazi terror was laid bare. Huge numbers of people were on the move as refugees and soldiers alike returned home. Confrontations between the Soviet Union and United States escalated, turning the postwar peace into a dangerous new conflict that would become known as the Cold War.

It was during the war years that the artists we now know as Abstract Expressionists came into contact with the masters of modern art who had fled the turmoil in Europe. Many artists and intellectuals had left the great cultural centers of Europe as the Nazis gained power and extended their grip across the continent. New York became a wartime haven for those intellectuals and artists lucky enough to overcome the considerable barriers that the United States erected against the influx of Jews and socialists seeking to escape the Nazis and

their collaborators. Some of the most renowned European minds found work at the New School for Social Research in Greenwich Village and at Columbia University farther uptown.

In the chapters that follow, Richard Klin and Lily Prince offer a wonderfully concise and accessible introduction to Abstract Expressionism. They bring the major painters to life and present some of the brilliant female artists who are too often left out. And they beautifully recreate for us the New York City of the 1930s, '40s, and '50s—a city bursting with optimism, a city of jazz, of improvisation, of creative energy. This was the New York that overtook the tired, war-ravaged capitals of Europe and, as Klin explains, created some of the most influential artwork ever made.

Cultural historians have tried to understand what sparks rich new artistic moments such as this. Some scholars have suggested, for example, that the early Italian Renaissance was fueled by an influx of artists and intellectuals who had fled the Byzantine Empire as it fell to the Ottomans. If that was the case, was there a twentieth-century parallel in which leading modern artists and thinkers from Europe functioned as a catalyst for a new generation of American painters? There is no question that the early work of Jackson Pollock, Mark Rothko, Willem de Kooning, and others now called Abstract Expressionists were profoundly influenced by Surrealist strategies that drew on the psychoanalytic theories of Sigmund Freud and Carl Gustav Jung. These strategies were designed to outwit the conscious self and in this way gain access to the hidden realm of the unconscious mind—what was believed to be the wellspring of raw creativity.

One of the hallmarks of Abstract Expressionism is that it is not

a unified style. The term is better used as a name for a group of like-minded artists who each developed their own abstract visual language. This happened in the years immediately following the war. In 1947 and 1948, the Abstract Expressionists evolved more purely abstract styles and transformed the subjects of their work. Where they had once relied on Surrealist technique and narrative subject matter such as ancient Greek mythology to grapple with the dramas of human experience, American artists in the postwar years found a new form of abstraction to be the most powerful visual language with which to articulate the human condition.

Jackson Pollock upended 500 years of painting technique when he laid huge unprimed canvases on the floor and dripped, splashed, and dribbled house paint from gallon cans with clotted brushes and sticks, all while walking around and stepping into his paintings as if they were canvas arenas. His radical shift from the vertical plane of the easel to the horizontal plane of the canvas spread across the studio floor was both physical and perceptual. Pollock was now able to use gravity as he let ribbons of enamel paint arc in the space above the canvas. When the paint landed it functioned like choreographic notation, recording the movements of the artist through space and time. Each line, skip, drip, pool, and arabesque reflected a turn of Pollock's body, a gesture, a decision. Painting was no longer about depicting a landscape or a face or even the academic formal concerns of earlier abstract art. Pollock's art is about something else entirely. It is about the act of improvisation and the creative risk of invention. It is about its own making.

Mark Rothko's art couldn't be more different. Where Pollock is

all energy and action, Rothko's large soft-edged clouds of brilliant luminous color are intensely quiet and nearly still. To stand in front of a Rothko is to feel time slow until it stops. The viewer enters a space constructed by the interactions of lush colors that sometimes seem to exist on the edge of perception. Rothko defines space through color, but the complexity of his colors create volumes in the spaces of his canvases that are wildly ambiguous. The viewer is enveloped and unmoored by shifting forms and the subtle interplay of light and color. We are invited to lose sight of our petty concerns and stand alone, confronting profound questions of beauty and existence and the emotions that accompany them.

Abstract Expressionism has been called the first truly American art. It is sometimes seen as an expression of American individualism, of the American experience in the mid-twentieth century. There is some truth in this, but these artists were also deeply concerned with the whole of human experience, and they used their art to better understand the profound and universal questions raised by the violence and beauty of our modern world.

Dr. Steven Zucker is co-founder and co-creator of the Webby Award–winning multimedia website Smarthistory. A specialist in 20th-century art and theory, he has served as chair of Art and Design History at Pratt Institute and as dean of the School of Graduate Studies at the Fashion Institute of Technology (SUNY), as well as chair of its Art History Department. He has also taught at the School of Visual Arts, Hunter College, and at the Museum of Modern Art in New York City.

A nyone who has viewed the movie *Full Metal Jacket*, Stanley Kubrick's opus of the Vietnam War, is unlikely to forget Hartman, the lethal drill sergeant. The role was played by R. Lee Ermey, who had been a real-life Marine drill sergeant and was given permission to improvise—from his own experience—much of his dialogue. Most of that dialogue was a relentless stream of imaginative, degrading insults. "You're so ugly," he spits out at one hapless recruit, "you could be a modern-art masterpiece!"

At some point, drill sergeant R. Lee Ermey probably hurled that exact insult. And no doubt the average Marine inductee knew full-well the insult implied in being called a *modern-art masterpiece*: something really, really odd-looking, if not downright hideous. Drill sergeants and their Marine inductees, it's safe to say, were probably not regular museum-goers. Yet here was a reference to modern art—in basic training, no less.

The idea of modern art entered the vernacular very quickly. More often than not, as in *Full Metal Jacket*, it was a

Abstract Expressionism references a specific group of painters who emerged after World War II in and around New York City.

term of derision. In more polite circles than a Marine drill sergeant's, it often inspired a sort of amused contempt: Modern art was pretentious nonsense, art that anyone's child could make. Monkeys, it was said, could make it too. (Of course, modern art also generated plenty of admiration.)

The phrase *modern art* is an imprecise, catch-all term that lumps together, say, Pablo Picasso in the early part of the twentieth century and Andy Warhol's soup cans 50 years later. Most often, though, the idea of modern art references a specific group of painters who emerged after the end of World War II, clustered in and around New York City: the Abstract Expressionists.

The Abstract Expressionists were a group of men and women (the women, as was so often the case in those sexist times, receiving less than their critical full due) whose formation was one of those cultural chain reactions similar to other postwar phenomena: the rise of bebop and modern jazz, for example, or the emergence of the Beat Generation writers and poets. These comparisons are not arbitrary. Painters, musicians, and writers were all centered in New York City at the same time, busy crafting new modes of expression to deal with a radically changed and changing world. They inhabited the same space—metaphorically and literally. Of course, artistic cross-pollination is nothing new. Historically, painters, writers, and musicians have certainly been more than aware of each other's work. But the intensity of these back-and-forth interrelationships was unprecedented: Abstract Expressionism, bebop, and the Beats all mirrored each other, like a constant multimedia ferment.

Jackson Pollock was the first of the Abstract Expressionists to achieve popular fame. Nobody had seen anything quite like it. It appeared that this painter perched himself on a large surface and, almost maniacally, began

flinging streams of paint at random. "Jack the Dripper," he was called.

Of course, anyone who has actually *looked* at Pollock's artwork can see that this is patently absurd: There is a distinct artistic ethos that governs his painting. In any event, the attention Pollock generated, for good and ill, was a prototype of the public's conception of these newfangled painters. For one, artists could now achieve celebrity status, which at the time was uncommon in and of itself. Pollock's work generated a host of misconceptions, tempered with an intense curiosity, both of which continue to this day.

The hard-drinking, hard-living Pollock was larger than life, and this also became part of the developing folklore of Abstract Expressionism. These American painters were not European *artistes* sequestered away in some salon, sipping absinthe. The Abstract Expressionists inhabited saloons, not salons.

Much of the Abstract Expressionist mythos centered around Greenwich Village and the iconic Cedar Tavern, where the painters rubbed shoulders,

smoking and drinking long into the night. And unfortunately, the story of Abstract Expressionism is also a story of excess and of ruined lives.

If one could look past the flamboyance, it was apparent that the Abstract Expressionists were grappling with some intensely serious political and social issues. Abstract Expressionism came of age at a time when the world, put simply, was a mess. The litany of what these painters had seen over the years was numbing: depression, fascism in Europe, world war, and now cold war. The Abstract Expressionists, having witnessed all this, could not be expected to focus on the conventional. "It should be plain in this second half of the twentieth century," asserted Harold Rosenberg, one of Abstract Expressionism's chief theorists, "that painting and sculpture have been striving to become something different than pictures on the wall or forms quietly standing in a corner of a room or garden."

> The Abstract Expressionists were also following in a distinct artistic lineage... of tearing down existing strictures...

The Abstract Expressionists were also following in a distinct artistic lineage—like T.S. Eliot, like James Joyce—of tearing down existing artistic strictures to create something new, something bold.

The Abstract Expressionists upended the art world. For the first time, New York City—not Paris, not Europe—became the artistic epicenter. They helped shape the spirit and culture of the times; they changed the conception of what we see and how we see it. The wide arc of their influence still reverberates today.

What Abstract Expressionism *Isn't*

Anyone searching for a precise, codified definition of Abstract Expressionism is, sadly, bound to come up short. The Abstract Expressionists were the most famous contingent of painters in the history of American art. They were emphatic about what art should and shouldn't be, but they were equally emphatic about *not* creating a concise, manifesto-driven movement with all the defined strictures that implied. They were going against the grain of the established art world. The established art world had definitions and rules. The Abstract Expressionists, to say the least, weren't enthralled with rules.

The very term *abstract expressionism*, as a matter of fact, was a label not of these painters' own choosing, but a name imposed by others. The wider art world of critics, curators, and gallery owners needed a good, shorthand tag line to describe this new, emerging school of painting. *Action painting* or simply *the New York School* came into parlance. But *Abstract Expressionism*—a phrase that had been floating around for a while and predated these particular painters—was the name that stuck.

Even the precise definition of who is and isn't an Abstract Expressionist is sometimes up for debate. And to muddy the waters even further, there is another group of artists called the *second-generation Abstract Expressionists*, who came up slightly later in the chronology.

On many levels, this vagueness of definition is the norm when it comes to new creative movements. That legendary coterie of American writers during the 1920s, for example, did not proclaim their intent to go off and create the "Lost Generation" school of literature; it was something that evolved. Likewise, the revolutionary jazz musicians who emerged after the end of World War II—musicians who, not incidentally, had a huge impact on the Abstract Expressionists—did not convene a meeting to announce to the world that a new form of jazz, called bebop, was about to be launched. The nature of artistic movements stems from creative alchemy, those unique

historical and cultural circumstances when the right people come together at the right time to forge something that had never been seen or heard before. The same very much applies to the Abstract Expressionist painters. Their emergence cannot be fully explained.

Another complicating factor when it comes to truly defining Abstract Expressionism is the curve balls thrown by the painters themselves. These brash new artists consciously positioned themselves in direct opposition to the art establishment. For that matter, they consciously positioned themselves in opposition to stuffy societal mores in general. Metaphorically, they were throwing a brick into the window of the American art world. And if that brick also landed in other windows, that was okay too. Definitions, to the Abstract Expressionists, were confining, limiting. "To classify," Mark Rothko, one of Abstract Expressionism's principal talents, asserted, "is to embalm."

> **These brash new artists consciously positioned themselves in direct opposition to the art establishment.**

The painters also had disparate styles. While they shared many of the same influences and creative impulses and certainly learned from each other, the Abstract Expressionist painters had widely varying techniques and worldviews. This, too, is not uncommon when innovations in art and music come on the scene. The new wave of rock 'n roll in the 1970s, for example, is often treated as a discrete, specific movement even as that view blurs the huge distinctions between the street-smart Ramones and the art school–cerebral Talking Heads. Both bands came out at the same cultural moment, yet they were worlds apart. Likewise, the AbEx (short for Abstract

Where They Came From

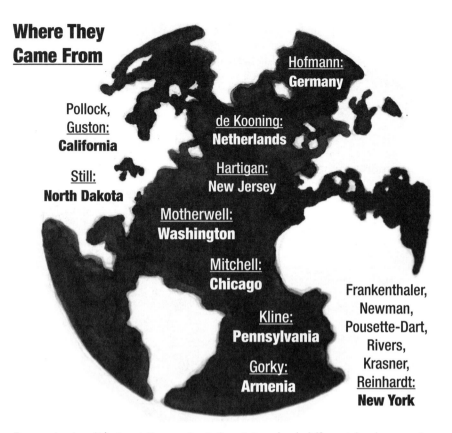

Pollock, Guston: **California**

Still: **North Dakota**

Hofmann: **Germany**

de Kooning: **Netherlands**

Hartigan: **New Jersey**

Motherwell: **Washington**

Mitchell: **Chicago**

Kline: **Pennsylvania**

Gorky: **Armenia**

Frankenthaler, Newman, Pousette-Dart, Rivers, Krasner, Reinhardt: **New York**

Expressionism/Abstract Expressionist) painters had different backgrounds, personalities, and behavior patterns. What came out on their canvases reflected these differences. It was very much an individualist's way of approaching painting, which makes it harder to ascribe stylistic specifics to AbEx as a whole. The artists were *militantly* individualistic. An encapsulated definition of what they were all undertaking was intrinsically difficult: the aims and processes varied from one painter to the other.

The rough-hewn Jackson Pollock was very much a product of the American West. Willem de Kooning, raised in the Netherlands, came to the United States as a ship's stowaway. Joan Mitchell was the product of a well-heeled, artistic Chicago family. In many respects, these painters didn't have much in common. What they *did* have in common, of course, was crucial: The thrown brick heard 'round the art world.

So ... What Exactly (More or Less) *Is* Abstract Expressionism?

Abstract Expressionism may have lacked a concise definition, but the specifics far outweighed the differences: It was, after all, a discrete movement. The name itself is instructive. These were abstract painters, disregarding representational strictures. There was not much regard given to recognizable objects or even painting basics like the horizon line.

But the *expressionist* component was equally vital. The AbEx painters would have been horrified to have their work regarded as simply academic exercises in space and shapes, or unconventional painting simply for the sake of being unconventional. They were undertaking expressive studies in human emotion—sadness, fear, happiness—and to do these expressive studies they reached out into the greater world and into their own subconscious.

What else? The AbEx painters painted large. Many had gotten their start during the Depression, painting—under the auspices of the New Deal— large, bold murals, and this carried over into their artwork a decade later. Abstract Expressionism also took jazz's improvisatory ethos and transferred it to the canvas. They often used unconventional material, such as sign paint and collage. They were based in New York City.

The fact that they were centered in New York was vitally important for a number of reasons. The fabled city itself—massive and colorful—had a huge impact on Abstract Expressionism's collective psyche.

New York City after World War II was a teeming, frenetic place, providing enough grist for any art in any medium. With Europe in ruins, the city had

emerged as the true international colossus. New York was the new Rome, with all that implied: a cacophony of highs and lows. Musicians, painters, writers, actors, and poets made their way to New York, which became a creative incubus with ample opportunity for artistic cross-pollination. It was a feast for creative types and bohemians. And it was also, of course, noisy, dirty, and poor. New York City—in all its grand contradictions—pulsated throughout much of the Abstract Expressionist oeuvre.

There was an equally significant practical aspect: The painters lived and worked in close proximity to each other. It was a concentrated space. Those sharing a like-minded worldview could interact on a constant basis (a condition that applied to all creative types, not just painters)—for better and for worse.

These upstart painters coalesced in Lower Manhattan. In a variety of ways they began to find each other. It was like sending out a beacon—sooner or later, you hope, someone flashes a light back at you. In crowded, downtown New York, the beacons flashed back and forth. In cheap cafeterias, bars, and galleries, like-minded painters bonded.

In 1949 that contingent of painters who soon emerged as the Abstract Expressionists rented a loft that became known as the Club, a place to meet and exchange ideas on a regular basis. A few years later, a seedy downtown bar called the Cedar Tavern became the legendary nexus of Abstract Expressionism, where the painters could be found night after night. The rough-and-tumble of Greenwich Village functioned as the AbEx training ground and salon.

Another key component to this movement was so overt that it risks restating the obvious: Abstract Expressionism was, well, *abstract*. By its

very intent, it eschewed the representational and emphatically rejected the notion of painting cheery, inspirational studies of fields and mountains. Pastoral views were, of course, in short supply in New York City. (Just for the record, though, a good deal of the AbEx body of work *does* reference beauty and nature.) For the AbEx painters, there was a larger issue at hand. Their intent was to look elsewhere—far elsewhere, in many cases—for artistic inspiration. These painters set out in all manner of ways to dispense with conventional notions about what painting should be. Abstract Expressionist painters mined the subconscious, which was hardly a common motif in American painting. They used unconventional materials to make their artwork; some even utilized commercial paint, which was designed for use on signs and billboards. What sort of painter did *that*? Abstract Expressionism also incorporated music and literature into their paintings—and this was not just a passive interest. Jazz was pulsating all over New York City, just a

stroll away from the artists' studios or the Cedar Tavern. It was just a stroll away from *anywhere*, really, which was the beauty of living in New York City.

Another common element of their aesthetic was a theoretical emphasis on the flatness of the canvas. For centuries, painters had executed their own special trickster magic: fooling the viewer into forgetting that what they were gazing at was, after all, a simple rectangular slab with paint all over it. Accordingly, painters had used the tools of their trade to convey that there was much more to be seen than a mere chunk of canvas. There was the illusion of depth, of perspective, of space, out of which new worlds could be created. The creative magic was loosely related to that of writing. In much the same way, writers historically didn't want to draw attention to the fact that a book was simply a bound stack of paper with print all over it.

> ...the AbEx artists painted big: large canvases and bold, gestural brushstrokes.

They didn't want to draw attention to the fact that Madame Bovary wasn't an actual person or that the events in *Crime and Punishment* didn't really happen. This all may sound rather obvious, but it's not. We like to lose ourselves in art and writing.

But the Abstract Expressionists were having none of that. Rather than hide the fact that a canvas was just that—a canvas—they trumpeted its flatness, putting that attribute front and center in their artistic ethos. If

The Wizard of Oz birthed the classic metaphor of not looking at the man behind the curtain, Abstract Expressionism said, "Yes, go ahead—look behind the curtain!" And partially because of this, the AbEx artists painted big: large canvases and bold, gestural brushstrokes. This decoding—pointing out that a painting was a canvas—was not solely an invention of the Abstract Expressionists. The nineteenth-century French painter Claude Monet, for example, executed large-scale paintings with an absence of the horizon line and attention to brushstrokes—traits associated with Abstract Expressionism.

If the Abstract Expressionists did not invent the flatness concept, they drove the point home, breaking down painting to its nuts and bolts. A painting, Abstract Expressionism declared, was a physical construction, a flat surface with paint. And who put that paint there? The painter. The Abstract Expressionists took full authorial responsibility. And, more often than not, the painters' personalities matched their outsized artwork.

This, too, became a central theme of the AbEx saga. The painters themselves could be eccentric, idiosyncratic, or downright weird. Many of them drank and smoked; they lived large; they burned out; some died young. Jackson Pollock was the most obvious, extreme example, but as a group, these painters were in the mold of the Beat writers, known perhaps more for their bohemianism than for their actual artistic output.

Social and political themes sometimes made their way into Abstract

Expressionism, but the movement generally steered clear of overt commentary. Most of the painters did have strong political feelings, and many had been very politically active. They had witnessed the worst of the twentieth century: the Great Depression, the rise of fascism in Europe, the historic carnage of World War II. The postwar era did not seem to offer much in the way of redemption or hope. The advent of the nuclear age now meant that, with the touch of a few buttons, the entire globe could be obliterated. Anti-Communist hysteria continued to fester, and the United States was busily transforming itself into a homogenized, suburban society. All of this, to say the least, did not bode well for iconoclastic painters.

Thus, the sociopolitical aspect of Abstract Expressionism is hard to categorize—one more reason why it's hard to ascribe specific definitions to this movement. The political content is a little tricky, as befits a school of art that did its best to avoid overt definitions. Yes, some expressly political content could be found in the AbEx oeuvre. Painter and printmaker Philip Guston, for example, incorporated images of the Ku Klux Klan into his work. But in essence, the Abstract Expressionists painted what they saw *metaphorically*.

> They had witnessed the worst of the twentieth century: the Great Depression, the rise of fascism in Europe, the historic carnage of World War II.

They were not in any way aiming for social realism. Even the most left-wing of the bunch—like Ad Reinhardt, like Barnett Newman—were overtly opposed to crafting representational paintings that depicted strikes or poor people or hopes for a better tomorrow. This was a conscious choice and

therefore a little puzzling, considering how political so many of the painters were. But there it was.

What the Abstract Expressionists *did* explicitly portray—"explicitly," of course, in the abstract sense, which really wasn't *that* explicit—was a harsh, damaged world and a United States bordering on dystopia. That view would not and did not encompass specific issues. "The art that holds up the crooked mirror to the audience," Harold Rosenberg commented, "is timely not with regard to art, but with regard to society." The crooked mirror was not always pleasant to look at, but it was accurate. And it was vital. This is where Abstract Expressionism's political commentary came in: both nebulous and definite.

> **"The art that holds up the crooked mirror to the audience…"**
> – *Harold Rosenberg*

If *nebulous and definite* sounds contradictory, it *is* contradictory. This was part of the usual AbEx pattern: It didn't want you to get too comfortable with definitions and strictures.

Soon after the United States entered World War II in 1941, the Selective Service released an extensive list of semi-skilled professions that were not to be exempted from the draft. Clerks, messengers, office boys, and shipping clerks, it was specified, were required to serve. The list continued: watchmen, doormen, footmen, bellboys, pages. And sales clerks, along with filing clerks, hairdressers, dress and milliner makers, and designers. Interior decorators came next. Then—last and certainly least, underscoring its monumental unimportance—came *artist*.

> **The mere fact that the Abstract Expressionists boldly proclaimed themselves to be painters was ... a striking development.**

The mere fact that the Abstract Expressionists boldly proclaimed themselves to be painters was, in and of itself, a striking development. From today's vantage point, this is difficult to comprehend: What, exactly, is the big deal about declaring yourself a painter?

In 1949 it *was* a very big deal. There was certainly a venerable tradition of American painting. Around the time of World War I, a cohort of American painters had begun exploring modernist motifs. The Abstract Expressionists were not operating in a total and complete vacuum. But even with all that, the beacon of modern, innovative painting came from Europe. Paris was still recognized as the international capital of the art world. In the

culturally stunted United States, painting was often relegated to the side. Painters—per the Selective Service—could hang out with the bellboys and shipping clerks.

In the public mind, painters were often oddball *and* often foreign—and most likely amoral *and* foreign, two things that seemed linked. Then there was the opposite stereotype: Art lessons were the domain of old-lady teachers; painting was an activity fit only for girls and sissies.

So the AbEx painters had much to contend with. The public perception of painters was contempt or indifference, or a combination thereof. An uber-macho, hard-living ethos took hold among many of these painters. Women were included, but they had to work extra-hard to be one of the boys. And this became a central trope in the lore of Abstract Expressionism: the hard-drinking, burning-the-candle-at-both-ends painter. Those traits, of course, were not universal in the AbEx world; and not all the painters were unrepentant hell-raisers. But the traits were there, and they were there in force. That, to say the least, was too bad. The dissipation would take its toll.

The Abstract Expressionists also loudly proclaimed themselves to be *American* painters. There is something counterintuitive about this: Abstract Expressionism was developing a critique about the poison running through American society while, at the same time, trumpeting its own Americanism. The context at the time, however, was very different than it would be today. "I believe that here in America," Barnett Newman wrote, "some of us, free from the weight of European culture, are finding the answer...."

The Abstract Expressionists were heavily influenced by European painters, but they also chafed under Europe's long shadow. Sometimes their irritation expressed itself in overt contempt. "Picasso and Matisse," the painter Jack

Tworkov wrote in 1953, "are extremely facile. Either one could as well have been a stage designer, a chic window-display artist, an engineer, an industrial designer or a magnificent ultra-smart tailor." Ouch! The protégé—American art—was eager to displace its mentor, European art.

In the previous decades, American literature had come into its own, assuming a position of global importance. A new generation of writers were crafting an impressive body of work. They were using innovative, modernist literary techniques and fusing them with their own raw material: the American upbringing, the American orientation. They were American writers, to be sure, but they were proudly, emphatically taking their rightful places in the canon of world literature.

Even in the late 1930s, Clement Greenberg wrote, "Most of the artists I knew did read the New York art magazines, but only out of a superstitious regard for print that they shared with most other people; they did not really take seriously what they read. Art publications from France … were another matter; these kept you posted on the latest developments in Paris, which was the only place that really mattered." Now, by issuing the declaration that they were American painters, the Abstract Expressionists were serving notice that they were ready to assume a front-and-center role in the art world. They would no longer be Europe's junior partner—a Europe that, not so tangentially, now lay in ruins.

Meanwhile, there was another artistic practice with European roots that was being re-jiggered by Americans: Method acting. This innovative set of techniques called for actors to immerse themselves thoroughly in any given role, eliminating artifice and getting to the inner core of the character. There were some pronounced similarities between the Method actors and

the Abstract Expressionist painters. Mark Rothko made the link explicit: "I think of my pictures as dramas," he said. "The shapes in the pictures are the performers." "When I am *in* my painting," Jackson Pollock related, "I'm not aware of what I'm doing." Again, this sort of sentiment—to be utterly lost in a role—could have come from any Method actor.

Harold Rosenberg elaborated on the point. "At a certain moment the canvas began to appear to one American painter after another as an arena in which to act—rather than as a space in which to reproduce, re-design, analyze or 'express' an object, actual or imagined," he wrote. "What was to go on the canvas was not a picture but an event." With the substitution of a few words, this passage could have come from any drama workshop. That mode of thinking had never been associated with painting in the past. Painters had always immersed themselves

Ornithology?

in their art, of course, but not like this.

Method acting also dispensed with the time-honored notions of proper elocution and actorly decorum. Method actors mumbled; they appeared in their undershirts like Marlon Brando in *A Streetcar Named Desire* (stage 1947, film 1951) and bellowed at the top of their lungs. Likewise, the Abstract Expressionists turned up their collective noses at high-blown theory or rubric, which they saw as European relics. "Aesthetics," painter Barnett Newman opined in what became a famous AbEx epigram," is for the artists as ornithology is for the birds."

Some of this was posturing. The Abstract Expressionists, as a rule, knew their aesthetics and were quite erudite. But the Newman quote was indicative of a prevailing mindset. To be an AbEx painter was, on some level, akin to being the smart kid in class, hiding his copy of *War and Peace*.

Stieglitz and his Circle

The Abstract Expressionists did not dream up American modernist painting all on their own. Artistic innovation is not created in a vacuum. The Abstract Expressionist painters took inspiration and craft from notable artists of previous decades.

The photographer **Alfred Stieglitz** was hugely influential, both as an innovative photographer and as a catalyst for spreading the gospel of modernism to the United States. In the early part of the twentieth century, he launched the Photo-Secessionist movement, which was dedicated to elevating photography into an art form in its own right. In 1905 Stieglitz established the Little Galleries of the Photo-Secession on 291 Fifth Avenue—immortalized as simply 291. It was via 291, which soon branched out far beyond photography, that Americans could first view the new wave of art emanating from Europe: Pablo Picasso, Henri de Toulouse-Lautrec, Henri Matisse, and Paul Cézanne. That gallery closed in 1917, but Stieglitz went on to establish others, which exhibited such pivotal American modernists as Arthur Dove, John Marin, and Marsden Hartley. Stieglitz married—and photographed—painter Georgia O'Keeffe, herself a pivotal force in the development of American art. Stieglitz was the connecting thread for this early chapter in American art innovation.

Arthur Dove had his first one-person show at 291 in 1912. His

nature-inspired canvases were emphatically modernist, but they failed, sadly, to find much of an audience. Dove had spent some time painting in Paris, and his work was appropriately sophisticated. At the same time he exhibited a certain all-American orientation. "I can claim no background," he stated, "except perhaps the woods, running streams, hunting, fishing, camping, the sky." A modernist painter touting the value of fishing and hunting was none too common, but Dove was an ardent believer in the spiritual properties of the natural world. He tried to convey the concept of *synesthesia*—the idea that sounds can be expressed via colors and shapes—in his artwork. *Foghorns* (1929), for example, is a painting made up of shapes that do, in fact, strongly connote the distinctive foghorn sound. That is the epitome of stretching artistic boundaries —multimedia by inference.

He tried to convey the concept of *synesthesia*— the idea that sounds can be expressed via colors and shapes— in his artwork.

Marsden Hartley, Maine born and bred, was part of that coterie of painters who first gained attention thanks to the 291 Gallery. After a harsh, poverty-stricken upbringing, he studied art in Cleveland, Ohio, and then settled in New York City in 1899. A sojourn in Paris and Berlin from 1912 to 1915 served as the catalyst for his groundbreaking work. Hartley imbibed Europe's heady intellectual and artistic ferment—and, as a closeted gay man in the

repressive United States, he was freed up personally and artistically by the looser, more open German gay subculture. Hartley was also a serious poet. His lifelong attraction to German culture led, after 1933, to some uncomfortable juxtapositions. Although not an ideologue, Hartley definitely was enamored with many aspects of Nazi Germany. "I am not a 'book of the month' artist," he declared, "and do not paint pretty pictures; but when I am no longer here my name will register forever in the history of American art and so that's something too." In this respect, he was entirely correct.

John Marin, in his lifetime, gained extraordinary renown. In 1948 *Look* magazine polled art critics and museum heads across America as to who was the country's greatest artist; Marin ranked first. Sadly, his posthumous reputation did not come close to matching his stature during his lifespan. The *Look* story has become an essential part of the Marin legacy: so much fame in his lifetime, which amounted to little in terms of a posthumous reputation. Marin died in 1953, just as Abstract Expressionism was coming into its own, and his fame in the art world quickly disappeared. Underestimating John Marin, though, is a mistake. His use of color and line made him an innovative talent. He was very conscious of the links between painting and music; his utilization of the underappreciated medium of watercolor was gutsy and idiosyncratic. (Watercolor had been considered a medium for girls.) His works on paper—a very definite precursor to Abstract Expressionism in their emphasis on the flatness of the canvas— dispensed with time-honored illusionistic techniques. There is a direct connection from Marin's work to the Abstract Expressionists.

Georgia O'Keeffe's reputation, during her lifetime as well as posthumously, doesn't need much in the way of explanation. She is and was iconic. Her early artwork caught the eye of Alfred Stieglitz, who launched her career (as he did so many others) with a 1916 one-woman show at the 291 gallery. A romance developed, and the two were married in 1924. O'Keeffe took the natural world and applied what was in a sense an artistic magnifying glass: nature painting through a modernist lens. Increasingly captivated by the otherworldly New Mexico landscape, she settled there permanently after Stieglitz's death in 1946. O'Keeffe's art defies categorization. As she grew older, her work gained huge renown for its highly original, genre-defying character. O'Keeffe began to be seen as a pivotal figure in feminist art and finally became—quite simply—a personality: a solitary, austere presence in the New Mexico desert, living and working in spartan conditions up to her death at the age of 99.

All of these painters and artists, in one form or another, helped to spawn Abstract Expressionism. That legacy aside, their oeuvre stands very much on its own—a fascinating, multilayered body of work.

There is a lot of misery embedded in the roots of Abstract Expressionism. Most of the painters spent their formative years during the horrible era of the Great Depression. Today, over eight decades later, we know that those hard times eventually came to an end. During the 1930s, of course, there was no such assurance. The Depression, among other things, must have been terrifying. On top of the unprecedented economic devastation came historic natural devastation as catastrophic dust storms— the Dust Bowl—spread destruction over large swaths of the country. There was something of a Biblical pestilence to the 1930s.

In Europe, Italy was in the grips of Mussolini's Fascist regime; Adolf Hitler was rising to power in Germany; and the Spanish Republic, one of the great experiments in democratic government, was violently destroyed—with the help of Germany and Italy— by the army of Francisco Franco (as immortalized in Pablo Picasso's *Guernica*).

The painters who would spark Abstract Expressionism in the 1940s were intensely aware of what was going on in Europe and the rest of the world. Many were overtly political, with egalitarian or left-wing sensibilities.

And what was going on in the world, to say the least, wasn't very pretty. A wave of repression tightened across Germany and began to threaten the continent as a whole. The Nazis burned books, rounded up dissidents and gays, and launched anti-Semitic violence that only grew in ferocity. "Where books are burned," wrote the nineteenth-century German poet Heinrich Heine, "in the end people will burn." One didn't need prophetic powers to foresee the horrible outcome.[1] Nobody, of course, could have predicted that outcome's catastrophic scale. But the underpinnings were there for all to see.

> Artists reflect the world around them, and here was the genesis of Abstract Expressionism.

Artists reflect the world around them, and here was the genesis of Abstract Expressionism. It was an era without a lot of hope.

Many of the individual painters carried their own personal, geopolitical scars. Mark Rothko was born in brutally anti-Semitic czarist Russia; when he was a child, his family joined the masses of Jews flowing out of the Russian empire and Eastern Europe. Arshile Gorky narrowly escaped the Armenian genocide; his mother did not. Willem de Kooning's native Netherlands was overrun by Nazi Germany during World War II; his home city of Rotterdam was pulverized by German bombing.

How could these shocks and traumas *not* seep into the AbEx DNA? "The stuff of thought is the seed of the artist," Arshile Gorky stated. "Dreams from the bristles of the artist's brush.... I communicate my most private

perceptions through art, my view of the world." These private perceptions, for Gorky and the other AbEx painters, could be very dark indeed.

The poet W.H. Auden penned a sad, concise summation of those turbulent times in "September 1, 1939":

I sit in one of the dives
On Fifty-second Street
Uncertain and afraid
As the clever hopes expire
Of a low dishonest decade…

Beyond geopolitics, the Abstract Expressionists were responding to a broad-based trend in the arts that, in essence, called for breaking things down. Sinclair Lewis, in novels such as *Main Street, Babbitt,* and *Elmer Gantry* during the 1920s, took large chunks out of the cherished American mythos. Small-town America had been held up as the moral backbone of the United States, but Lewis's novels showed just the opposite. In his fictional canon, small-town America was, in fact, a snake pit of narrow-mindedness and hypocrisy. Organized religion was an out-and-out sham. The American businessman was an ignoramus.

The American South, in the

worldview of William Faulkner, looked like a backwater of disturbing oddness, haunted by the Civil War and its legacy of racial oppression. (Willem de Kooning, in fact, titled one of his paintings *Light in August*, after Faulkner's 1932 novel.)

> **Radical new terrain was being created, filling in the nooks and crannies of language and form.**

This great cultural arc was more than a mass indictment of societal ills. It also entailed a sense of exploration, of limitless possibility. Picasso and a host of European painters had dispensed with conventional, cherished notions of painting, just as Igor Stravinsky and others were dispensing with conventional, cherished notions of musical composition. In literature, James Joyce's novel *Ulysses* (1922) had opened up huge new vistas of what could be done by eliminating standard notions of narrative and space. It also delved frankly into areas that were forbidden in American literature, like sexual themes.

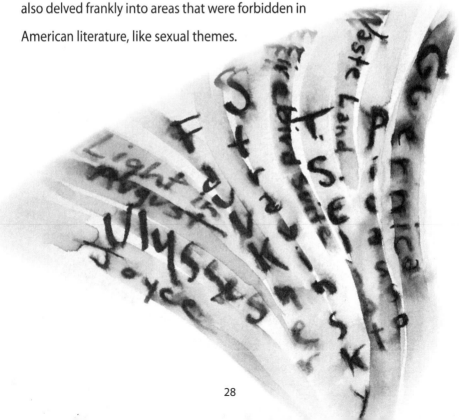

(The book and Joyce himself paid the price, as *Ulysses* was banned from the United States for a good decade.)

Let us go then, you and I, began T.S. Eliot's groundbreaking poem "The Love Song of J. Alfred Prufrock" (1915), *When the evening is spread out against the sky/Like a patient etherized upon a table....* How could the evening be compared to an anesthetized patient, of all things? What did that *mean*? Here was something very new; poetry in a scope that had not existed before. In fiction, John Dos Passos's mammoth *U.S.A.* trilogy during the 1930s utilized newspaper headlines and newsreel copy. Radical new terrain was being created, filling in the nooks and crannies of language and form. *Make it new*, went the dictum.

And that dictum applied to painters, too. The Abstract Expressionists in particular were determined—very determined—to make it new.

The Big Money (1936), *Newsreel LXII*

STARTS PORTEND EVIL FOR COOLIDGE

If you can't tell the world
She's a good little girl
Then just say nothing at all

the elder Way had been attempting for several years to get
a certain kind of celery spray on the market. The investigation
of the charges that he had been beaten revealed that Way had
been warned to cease writing letters, but it also brought to light
the statement that the leading celery growers were using a spray
containing deadly poison

As long as she's sorree
She needs sympathee

MINERS RETAIL HORRORS OF DEATH PIT

—*John Dos Passos, U.S.A.*

Let's Make a (New) Deal

On March 4, 1933, Franklin Roosevelt became president of the United States, signifying a tectonic shift in the American body politic. His activist New Deal, with its myriad social programs and initiatives, offered tangible hope to a nation dazed and impoverished by the unprecedented catastrophe of the Depression.

The painters who became the Abstract Expressionists were mostly clustered in New York City, living in isolated pockets. The life of a painter was already

> **Over a thousand painters quickly gained employment via the WPA.**

harsh. With the advent of the Depression, their economic circumstances became all the more dire. The Works Progress Administration (WPA) was a multifaceted initiative of the New Deal with a strong arts-oriented component. Directed by Harry Hopkins, the agency offered assistance in a wide array of media: literature, the visual arts, music, and theater. The WPA's Federal Art Project, launched in August 1935, specifically provided painters with an economic life raft: $20 a week. "Hell!" Hopkins said when questioned as to why artists were being included in the WPA. "They've got to eat just like other people." It was a miracle. "People dashed through the streets of the Village," one chronicler wrote, "clutching paintings under their arms, spreading the news from door to door."

Over a thousand painters quickly gained employment via the WPA. By 1936 the number had skyrocketed to 6,000 in a program that extended to all 48 states. Jackson Pollock found work with the Art Project, as did Ad Reinhardt, Mark Rothko, Lee Krasner, Arshile Gorky, Willem de Kooning, and Philip Guston—a virtual who's-who of Abstract Expressionism. With that princely sum of money, the painters could transform abandoned spaces into workable, productive studios.

The Art Project's bread and butter was the construction of murals: big, attention-grabbing visuals. Patriotic themes were thought to be ideal for murals, but the program's administrators apparently had not gotten the full measure of the artists they were dealing with. Arshile Gorky, for example, was tasked with helping to plan some murals for an administration building at Brooklyn's Floyd Bennett Field—an airport. By official decree, the mural needed to encompass "early legends and stories of man's aspiration to fly in a romantic period." In short, it needed to be inspirational. Gorky, who had never even been on an airplane, had different ideas altogether. He was more interested in the *feeling* of air flight and eventually submitted over 50 sketches, envisioning a ten-panel piece that would be divided onto four walls. (His murals did get included, though not on the grand scale he'd intended.)

> **...it was easy to discern the influence of the Federal Art Project on the AbEx love for big canvases and an emphatic, gestural style.**

By virtue of necessity, the WPA painters were required to work on a bold, large scale. In the subsequent decade, as Abstract Expressionism took force,

it was easy to discern the influence of the Federal Art Project on the AbEx love for big canvases and an emphatic, gestural style. Moreover, because of the WPA Art Project, these painters began to become aware of each other. It was the first stirrings of a community. Also for the first time, the motley crew were being formally recognized as *painters*: a professional, paid status bestowed upon them by no less an authority than the U.S. government (despite the rancor of the political right).

The Federal Art Project lasted until June 1943, by which time nearly 200,000 works of art had been created under its auspices.

The Federal Art Project lasted until June 1943, by which time nearly 200,000 works of art had been created under its auspices. The fate of most of them was truly sickening. In December 1943 thousands of WPA-sponsored pieces were auctioned off—and even more insultingly, auctioned off by the pound, as you would dispose of scrap metal.

The painters, as newly minted professionals, were compensated for their labors. This, perhaps, was the most crucial aspect to the Art Project. "The Project was terribly important," Willem de Kooning remembered. "It gave us enough to live on, and we could paint what we wanted.... [E]ven in that short time, I changed my attitude toward being an artist. Instead of doing odd jobs and painting on the side, I painted and did odd jobs on the side. My life was the same, but I had a different view of it."

The painters could stay financially afloat. It was still not in any way a comfortable existence. The wolf was always at the door, but these painters survived as viable artists. And that, at the time, was enough.

Tales of Hofmann

For the emerging community of painters in New York, the triumph of fascist rule in Europe—horrifying enough on every level—eventually began to have day-to-day immediacy. An exodus of painters, writers, poets, and free-thinkers of all stripes, Jewish and non-Jewish alike, began leaving a European continent that seemed increasingly to resemble a large-scale prison camp. New York City was a natural point of arrival for these refugees. And this is where a large contingent of European painters found refuge.

Hans Hofmann was one of those refugees. He was born in Germany in 1880 and moved to Paris in 1904. He had been personally acquainted with Matisse, Braque, and Picasso. Hofmann was a significant painter in his own right, but his main legacy became that of a legendary art teacher, conducting classes in New York City and at the bohemian enclave of Provincetown on Cape Cod.

Hofmann's teachings were undergirded by a strong theoretical base, notably his "push-pull" concept. The principle he taught emphasized the canvass's flatness—one of Abstract Expressionism's conceptual pillars—and put a premium on creating movement and depth by means of contrasting forms, textures, and colors. Each color, Hofmann postulated, should be answered by a counterforce. A change in one color on the canvas generated a change in the other colors.

Hofmann's theories were not synonymous with inflexible dogma. He gave his many students room to breathe, to find their individual voices. There was also a vital component of

spirituality and affirmation to his practice. He was unafraid to wax rhapsodic: "Your empty paper has been transformed by the simplest graphic means to a universe in action. This is real magic."

Hans Hofmann taught Helen Frankenthaler, Larry Rivers, Lee Krasner, and Joan Mitchell—some of the biggest names in Abstract Expressionism. (Another student was Robert De Niro, Sr., the father of the legendary actor, who had a long but obscure career as a painter.)

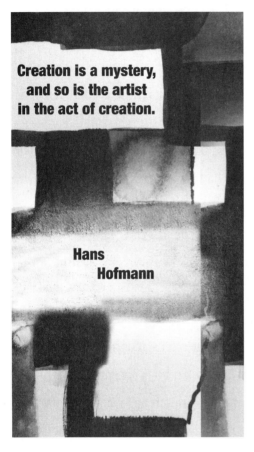

Creation is a mystery, and so is the artist in the act of creation.

Hans Hofmann

Hofmann had a dual role. He was renowned as a teacher of extraordinary prowess, and he himself was a forceful painter. Some of his works utilized a drip technique later made famous by Jackson Pollock. Not surprisingly, Hofmann was captivated by the Cape Cod seascape, rendering it in paint, ink, watercolor, and even crayon.

His paintings, like those of some other AbEx painters, wander into the realm of Color Field, an offshoot of AbEx. Landscape, too, is an important element in the Hofmann oeuvre. Indeed, there is an almost dizzying eclecticism to his painting, as if he were trying to imbibe each and every painterly motif that was expressed via Abstract Expressionism. Hofmann's painting output is generally accorded a second

tier in reviews of his influence; the teaching slot overshadows the painting slot, which is not quite fair.

Hofmann was an integral part of Abstract Expressionism but, to an extent, not *of* it. He was quite older than the others, distinctly foreign, and not inclined to hang out and drink with his fellow artists. His painting was certainly crafted with sophisticated AbEx motifs, but there was an exuberance to his work that is rare in the Abstract Expressionist oeuvre: a beautiful, lush symmetry to *The Golden Wall* (1961) and an almost carnivalesque buoyancy to *Shifting Planes* (1947). *Fragrance* (1956) manages to be exactly that—fragrant—as if one has wandered into a field of flowers or blossoms.

> He shows
> the vitality
> of matter,
> its creation and
> its destruction...
> —*Tennessee Williams*

The playwright Tennessee Williams, another denizen of Provincetown, knew Hofmann personally and loved his work. "Hans Hofmann paints," Williams wrote, "as if he could look into those infinitesimal particles of violence that could split the earth like an orange. He shows the vitality of matter, its creation and its destruction, its angels of dark and of light."

"We hear, smell, and touch space," Hofmann declared, giving voice to the true sensory experience of crafting not just visual art, but writing, music, and all art forms.

World War II in Europe commenced in September 1939. Within a year, France was under Nazi occupation. The idea of creating a new, American school of painting, independent of Europe, took on entirely different connotations under the horrible circumstances of a world at war. Paris, the

epicenter of the art world, was effectively shut down. American painters coalesced, more and more, into a distinct contingent. With Europe cut off, the Americans were *forced*, in a sense, to coalesce into that distinct contingent.

Among the influx of refugees arriving in New York was the flamboyant American expatriate Peggy Guggenheim, of the cultured, philanthropic Guggenheim family. Her father, Benjamin Guggenheim, had inherited the family mining fortune but perished aboard the *Titanic* in 1912. She was one of those unconventional, moneyed Americans who lived abroad, embracing the role of patron of the arts. In the Paris of the 1920s, she had presided over her own salon, rubbing shoulders with the likes of Ernest Hemingway, Ezra Pound, and the French writer, artist, and filmmaker Jean Cocteau.

Guggenheim had been married to the German Surrealist painter Max Ernst and had an abiding interest in painting. Blessed with deep pockets, she took it upon herself in 1942—now in the haven of New York City—to open a small gallery, choosing a name both audacious and prophetic: Art of This Century. The gallery opened to a great deal of publicity, but the ride was not exactly smooth. During a visit by First Lady Eleanor Roosevelt, one of Guggenheim's friends imitated Mrs. Roosevelt's distinctive, upper-class falsetto—unaware that the first lady herself was still in proximity. "Mrs. Roosevelt, evidently amused by his behavior," Peggy Guggenheim related, "turned to him smiling, and bowed."

Guggenheim set to work exhibiting the iconoclastic painting talent that was taking shape during the 1940s: Robert Motherwell, Hans Hofmann, Mark Rothko, Ad Reinhardt. She was especially enamored of the distinctive work of Jackson Pollock, who was garnering attention both for his innovative art as well as for his unstable, alcohol-fueled behavior. Pollock, Peggy

Guggenheim grew to feel, was the greatest painter since Picasso. It was a view that was not, to say the least, universally shared.

As hyperbolic as that pronouncement may have sounded, Guggenheim was in the right ballpark. Jackson Pollock certainly became the most famous painter since Pablo Picasso and the first American painter to achieve true celebrity status (as well as notoriety). And with that celebrity and notoriety, Pollock yanked Abstract Expressionism into the limelight.

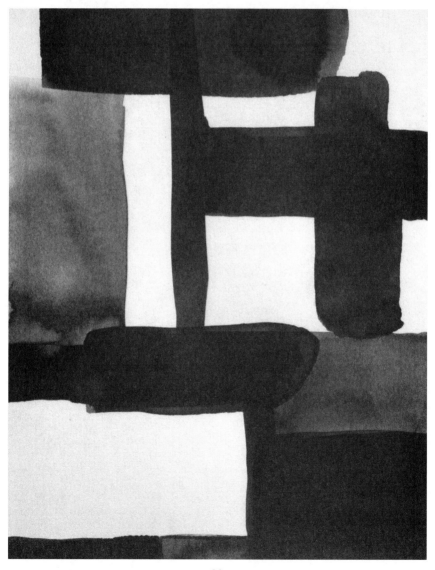

What is an artist?

"Well, I don't know what an artist is—but I know what makes an artist: I do know that only the man equipped with creative instincts and a searching mind is destined to become an artist. As an artist I do know that only the highest exaltation of the soul will enable the artist to transform the deepest and the weightiest of his experiences into a new dimension of the spirit that is art.

Creation is a mystery, and so is the artist in the act of creation.

Every great work is a new reality—but it is the life's work of an artist that creates a new dimension of the spirit. The life's work of an artist is 'the work of art….' It includes the whole behavior of the man, his ethical standards, and his awareness of his creative responsibilities.

Talent is everywhere—it does not make the artist. It is often a handicap because it invites cleverness, which always chooses the easier side of life."

—*Hans Hofmann, 1949*

Birth of the Cool

World War II came to an end in 1945. Along with the deep relief that the war was finally over, there was the sobering shock that this war had brought unprecedented slaughter and a Holocaust that had murdered gays, gypsies, and six million Jews. With the introduction of atomic weaponry, apocalyptic fears became even more apocalyptic: The whole world really *could* be obliterated. American politics took on an especially toxic overlay as anti-Communist hysteria took the eventual form of loyalty oaths, witch hunts, blacklists, and the demagoguery of Senator Joseph McCarthy. In 1947 the House Un-American Activities Committee hauled ten members of the movie industry in for questioning on their alleged left-wing sympathies (which, by anybody's reckoning, was not illegal). Most members of the group, known as the Hollywood Ten, refused to cooperate and were sentenced to prison terms. Upon their release, they found themselves blacklisted and unable to work. The blacklist spread far and wide, ruining the careers of actors, screenwriters, and directors. The fact that special venom was reserved for creative types was not lost on anybody.

Along with the fruits of Allied victory came a steady onslaught of fear. It appeared that there were many, many new reasons to be terrified: Communists were everywhere; the Soviets were our mortal enemy; and with the introduction of atomic weaponry, science had run amok. It made sense that the brooding, menacing noir genre emerged in film and literature. Noir was tricky and mysterious, with the distinction between good guys and bad guys blurred to the point of invisibility. Noir had some psychotic undertones: the protagonists of these books and stories could, in some cases, be pathologically unreliable.

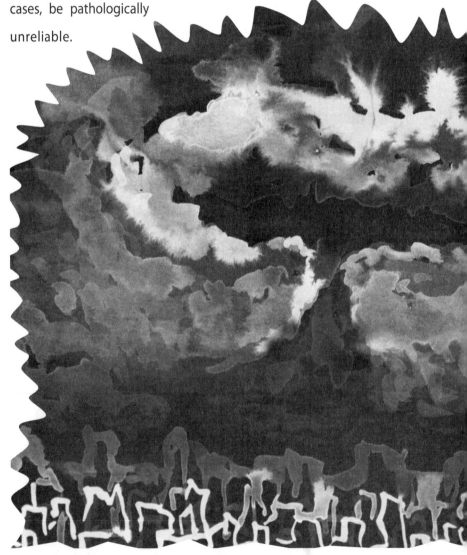

The reader couldn't even rely on a narrator's objectivity.

It also made sense that the 1950s turned out a whole canon of hair-raising science fiction films. To what extent were menacing creatures really out there? And how harmful were these secret new advances in science? If supposedly civilized Europe could rampage through two world wars, and if Hiroshima and Nagasaki could be vaporized in one fell swoop, perhaps aliens from other planets were not, conceptually, far-fetched. It was hardly far-fetched that science could be harnessed for malevolent, society-destroying purposes. The atomic bomb was frightening enough, but by the 1950s there was something even *more* destructive: the hydrogen bomb. And no sooner did the Second World War end, it seemed, then a new conflict began, this one in Korea.

Yet postwar America abounded in paradoxes. The United States had not seen its land invaded. The horrible tragedy of Pearl Harbor notwithstanding, its cities had not been bombed. While war-ravaged Europe was impoverished, America emerged as the new global behemoth.

The American standard of living became significantly easier as the postwar era progressed. There was a material comfort that would have been inconceivable just a decade before. The average citizen now had leisure time, a concept beyond anyone's imagination during the 1930s. Leisure time was for the idle rich. With the newfound prosperity, though, came mass conformity and homogenization. In the presidential election of 1952, witty, intellectual

Adlai Stevenson—derided as an "egghead"—had been crushed by war hero Dwight Eisenhower. The writer Eric F. Goldman quoted a professor's somewhat hyperbolic comments on Stevenson's electoral rout: "It's not just that a great man has been defeated. It's that a whole era is ended, is totally repudiated, a whole era of brains and literacy and exciting thinking." Creative people of all stripes had much to grapple with.

Still, a huge number of Americans were hungry for culture and eager to broaden their horizons. Financially, many people were comfortable enough to make this happen. It is not insignificant that the Ricardos and the Mertzes of TV's *I Love Lucy* traveled to Europe for 17 episodes in 1955–1956. Historically, a trip to the continent had been the domain of the well-to-do, the sort of thing that characters in Edith Wharton novels could undertake. Now even Fred and Ethel could traipse through the European countryside.

> The something new and attention-grabbing was, by loose consensus, Jackson Pollock.

Realization that there was a contingent of idiosyncratic, New York–based American painters slowly began to percolate. By the late 1940s, there had been a sea-change in the art scene. These painters were certainly not enjoying the fruits of fame or money, but they were no longer the ragtag band they had been back in the Depression. Rents in Manhattan were still affordable, and the painters banded together to lease space on Eighth Street in Greenwich Village that they quickly dubbed the Club. They gathered at the Club, they conducted discussions at the Club, they listened to lectures at the Club.

Steady critical attention began to be focused on these painters, and the press, always on the lookout for something new and attention-grabbing, came calling.

The something new and attention-grabbing was, by loose consensus, Jackson Pollock. He was colorful and rugged, in the Hemingway mode. His extremely unconventional work was eliciting attention. Pollock's paintings seemed to be riotous accumulations of drips and splatters. He painted not with the traditional easel and palette, but physically loomed over his work-in-progress, which was placed on the floor.

The specific antecedents of his drip technique were murky. Pollock was certainly not the sole inventor of this method. Nor, interestingly, was the drip technique always an intrinsic part of his work; it did not appear in full force until 1947. Such nuances were quickly cast aside, however, and on August 8, 1949

the mass-circulation *Life* magazine—with a readership far, far removed from bohemian Greenwich Village—ran a profile of this new sort of painter. The headline read: "JACKSON POLLOCK: Is He the Greatest Living Painter in the United States?" The inference cut two ways. Yes, he might in fact be America's greatest painter. Then again, there was plenty of room for doubt: Maybe he wasn't.

> **The idea of an American art celebrity was an absolute novelty in 1949.**

The idea of an American art celebrity was an absolute novelty in 1949. But there it was: Abstract Expressionism, as it came to be called, had pushed its way into the public's awareness in the person of Jackson Pollock. He, Willem de Kooning said, broke the ice.

Jackson Pollock: The Icebreaker

Jackson Pollock was born on a Wyoming sheep ranch in 1912, and the family moved to California shortly thereafter. His Western upbringing became part of the Pollock mythos. Fragile and troubled from an early age, he found a psychological lifeline through painting. Pollock studied, somewhat improbably, under the aegis of Thomas Hart Benton, painter of the American heartland.

> **Beneath Pollock's 90-proof bombast lay a serious, thoughtful practitioner.**

Pollock was an epic drinker with ongoing issues of mental stability. He enjoyed the dubious distinction of psychological problems so acute as to earn him a 4F draft classification, thus exempting him from military service during World War II. Hardened New York bartenders, accustomed to all manner of inebriated behavior, refused to serve him. He was often medicated, either by psychiatric design or excessive drink. The dissipation became a key component of his rough-and-ready persona.

Beneath Pollock's 90-proof bombast lay a serious, thoughtful practitioner. There was a deep-rooted spiritual side to him as well, having been influenced by theosophy and the teachings of Indian mystic Krishnamurti. His own paintings, Pollock said, were "memories arrested in space." There were also instinctive political leanings that tilted toward the populist and radical.

In many respects, Pollock mirrored Jack Kerouac (though not politically)—a sophisticated literary talent whose wild-man persona could overshadow his actual artistry.

> **Pollock was able to bring up a deep reservoir of inspiration and sensitivity.**

Pollock was able to bring up a deep reservoir of inspiration and sensitivity. There is an elaborate, swirling symmetry to his paintings, with an almost mathematical precision. His oeuvre is infused with unconventional media: enamel, aluminum paints. Critic Parker Tyler, writing about Pollock's work, saw that it had the "continuity of the joined letter and the type of curve associated with the Western version of Arabic handwriting—yet it escapes the monotony of what we know as calligraphy." There was a lot going on artistically, if obscured in the general hullabaloo about his destructive antics.

The 1949 *Life* profile generated instant fame. Here was the living embodiment of this brawny new American art that didn't kowtow to Paris: a T-shirted, masculine Westerner. Any notion that painting was somehow unmanly was no longer valid.

In 1950, New York's uber-prestigious Metropolitan Museum of Art mounted an exhibition that featured the cream of contemporary painting. Quite overtly, the radical innovators from downtown were excluded. This probably should not have been a great surprise, since the museum's director had once likened Pollock and his ilk to pelicans "strutting upon the intellectual wastelands." Incensed at the snub, the Young Turks of the New York art world circulated a much-publicized open letter castigating the museum's superficial exclusivity.

Life magazine, ever vigilant for culturally defining moments, assembled these outcasts—dubbed the Irascible 18—for a large group photo. Most of the artists, looking appropriately somber, appeared in the magazine in early 1951. So the barbarians were at the gates—and even worse, they were in the pages of *Life* magazine! In a taste of what was to come in this thoroughly masculine milieu, only one woman was privileged to be included, Hedda Sterne, who was positioned all the way in back and

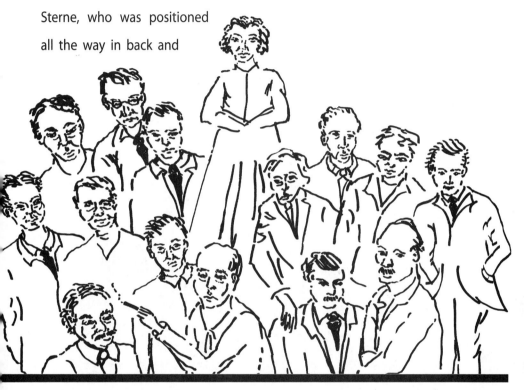

standing on a table, like a schoolmarm or someone's mother. (Sterne, the last surviving painter in the photo, died at the age of 100 in 2011.)

Sudden fame, which can be difficult for even well-adjusted personality types, was ultimately a disaster for the fractured Pollock. Often drunk or tranquilized, his stupor was misinterpreted as taciturnity. One projection after another was attached to him: the self-sufficient man of the West; the untutored oracle. His dissipation became truly startling: drinking to

excess, brawling, urinating in public, going beyond the bounds of painterly hijinks and wandering into behavior more typical of, say, the rock band Led Zeppelin. At one point his alcohol consumption totaled a *case* of beer a day. The self-destructive slide reached its inevitable, horrible conclusion in 1956, when an inebriated Pollock got into his Oldsmobile convertible with his young paramour, Ruth Kligman, and her friend Edith Metzger. The resulting car crash left Kligman as the lone survivor.

In a relatively brief amount of time, Pollock had been the pivotal force in radically reshaping the art-world order. Abstract Expressionism was an organized force, it had made it into the mainstream media, and—in due time—it conquered the art world. Returning to Willem de Kooning's metaphor, Jackson Pollock did break the ice—but he did more than that. He smashed the ice, crushed the ice, and ultimately froze to death. But he put AbEx on the map.

Abstract painting is abstract.
It confronts you.
There was a reviewer a while back
who wrote that my pictures didn't have
any beginning or any end.
He didn't mean it as a compliment,
but it was.
It was a fine compliment.
—Jackson Pollock, 1950

Ad Reinhardt

"Looking," Ad Reinhardt declared, "isn't as simple as it looks. Art teaches people how to see." By that criterion, Reinhardt qualified as a master teacher who taught people how to look—*really look*—at color.

As a student at Columbia University in the 1930s, Reinhardt had a thorough, broad-based orientation in the humanities. He fell under the sway of Meyer Schapiro, one of the era's pivotal art theorists. Reinhardt also had a stint as editor of *Jester,* Columbia's humor magazine.

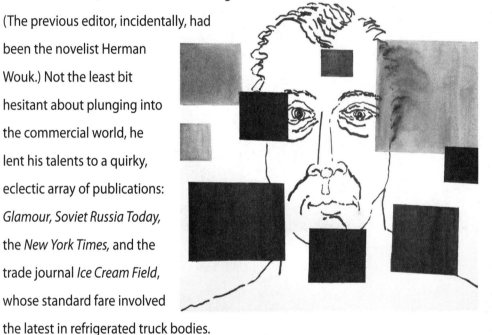

(The previous editor, incidentally, had been the novelist Herman Wouk.) Not the least bit hesitant about plunging into the commercial world, he lent his talents to a quirky, eclectic array of publications: *Glamour, Soviet Russia Today,* the *New York Times,* and the trade journal *Ice Cream Field,* whose standard fare involved the latest in refrigerated truck bodies.

Reinhardt also worked as an assistant to the cartoonist Crockett Johnson, later to gain acclaim as the creator of the imaginative children's classic book *Harold and the Purple Crayon.* In the 1940s, Ad Reinhardt's love of cartooning and radical political sentiment led to a slot at *PM,* the legendary left-wing journal.

There is an intangible exoticism at work in some of the color-suffused paintings of Ad Reinhardt, which befits a painter whose interests extended

far and wide: calligraphy, Asian and Islamic art, Buddhism. Around 1956 he dramatically switched gears to focus on large, imposing monochromatic work: solid blocks of blue, black, or red.

It was specifically the black-on-black artwork that began to occupy the majority of Reinhardt's artistic efforts until his unexpected death in 1967. His aim was to rid his painting of externals. The black paintings—primal, overpowering, even a little bit intimidating—certainly did just that.

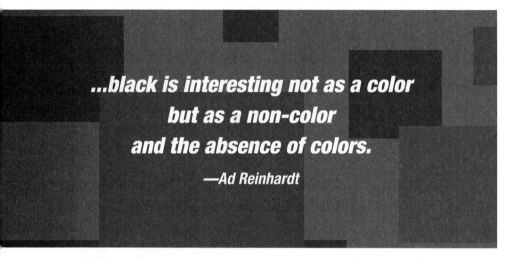

...black is interesting not as a color but as a non-color and the absence of colors.
—*Ad Reinhardt*

"As an artist," Ad Reinhardt said, "I would like to eliminate the symbolic pretty much, for black is interesting not as a color but as a non-color and as the absence of colors." Reinhardt had deliberately created an intense immersive experience for the viewer. The immediacy of this one overwhelming color (or *non-color*, depending on your choice of the scientific definition of *color*) forced a real consideration of *black* in all its manifestations. Black is, obviously, with us all the time; it is so much a part of our existence as to be taken utterly for granted. Ad Reinhardt, in a sense, played with that. With an almost single-minded obstinacy, he made people take a good, long look at this specific color/non-color.

Abstract Expressionism, not surprisingly, could overlap with the avant-garde and minimalism—and not just in painting. The composer John Cage's *4'33"*—often styled as *four minutes and thirty-three seconds of silence*—was a conceptual "musical" composition in which the performer and audience sat though exactly that: four minutes and 33 seconds of silence. The piece forced listeners to consider the properties of silence and the intrinsic value of ambient noise—another ubiquitous part of peoples' lives that, like black, basically goes unnoticed. Ad Reinhardt, John Cage, and other creative forces were taking the tangential aspects of life—the chunks that go basically unnoticed—and treating them as something important.

Just as Jackson Pollock's paintings were emphatically *not* the result of haphazard paint-splattering, neither was Ad Reinhardt simply globbing a heavy mass of black paint onto a large canvas. His monochromatic black paintings were, upon examination, not as monochromatic as they appeared at first. Reinhardt's sea of black subtly incorporated different shades and values. Gray, from time to time, made its appearance on the canvas. A pitch-black night, when you think about it, has its subtleties and gradations. The night is not *pure* and complete darkness. It shifts and gradually alters—and then it eventually ends, only to begin anew 12 hours later. "Black is not as black as all that," wrote the French poet Paul Valéry.

Reinhardt was blunt and impolitic in his opinions. His sharp-edged criticisms of Barnett Newman's art were deemed so inflammatory that Newman sued Reinhardt (unsuccessfully) for libel.

The painter Frank Stella succinctly summed up Ad Reinhardt's legacy. "If you don't know what they're about," Stella said, referencing his monochromatic works, "you don't know what painting is about."

Ad Reinhardt's Twelve Rules
for a New Academy

1. No texture. Texture is naturalistic or mechanical and is a vulgar quality, especially pigment texture or impasto. Palette knifing, canvas-stabbing, paint scumbling and other action techniques are unintelligent and to be avoided. No accidents or automatism.

2. No brushwork or calligraphy. Handwriting, hand-working and hand-jerking are personal and in poor taste. No signature or trademarking. "Brushwork should be invisible." "One should never let the influence of evil demons gain control of the brush."

3. No sketching or drawing. Everything, where to begin and where to end, should be worked out in the mind beforehand. "In painting the idea should exist in the mind before the brush is taken up." No line or outline. "Madmen see outlines and therefore they draw them." A line is a figure, a "square is a face." No shading or streaking.

4. No forms. "The finest has no shape." No figure or fore- or background. No volume or mass, no cylinder, sphere or cone, or cube or boogie-woogie. No push or pull. "No shape or substance."

5. No design. "Design is everywhere."

6. No colors. "Color blinds." "Colors are an aspect of appearance and so only of the surface." Colors are barbaric, unstable, suggest life, "cannot be completely controlled," and "should be concealed." Colors are a "distracting embellishment." No white.

"White is a color and all colors." White is "antiseptic and not artistic, appropriate and pleasing for kitchen fixtures, and hardly the medium for expressing truth and beauty." White on white is "a transition from pigment to light" and "a screen for the projection of light" and "moving" pictures.

7. No light. No bright or direct light in or over the painting. Dim, late afternoon absorbent twilight is best outside. No chiaroscuro, "the malodorant reality of craftsmen, beggars, topers with rags and wrinkles."

8. No space. Space should be empty, should not project, and should not be flat. "The painting should be behind the picture frame." The frame should isolate and protect the painting from its surroundings. Space divisions within the painting should not be seen.

9. No time. "Clock-time or man's time is inconsequential." "There is no ancient or modern, no past or future in art. A work of art is always present." The present is the future of the past, not the past of the future. "Now and long ago are one."

10. No size or scale. Breadth and depth of thought and feeling in art have no relation to physical size. Large sizes are aggressive, positivist, intemperate, venal and graceless.

11. No movement. "Everything is on the move. Art should be still."

12. No object, no subject, no matter. No symbols, images or signs. Neither pleasure nor pain. No mindless working or mindless non-working. No chessplaying.

Arshile Gorky

Sixteen-year-old Vosdanig Manoug Adoian arrived in New York City in 1920. He was an Armenian who had escaped from the demonic clutches of the Turkish genocide that had caused so much death and destruction to the Armenian people. Like many immigrants who were making a life in the New World, he decided to shed his foreign-sounding name. After briefly considering the all-American Archie Colt or Archie Gunn, he settled finally on Arshile Gorky, in large part because of his admiration for the Russian writer Maxim Gorky. The painter Gorky, never one to let facts get in the way of a good story, claimed at times to be the writer Gorky's nephew. (Maxim Gorky's real name, though, was Alexei Peshkov.)

He grew up in idyllic circumstances, the family held together by his pious mother. The idyllic circumstances were fragile, however, as Armenians were a distinct minority in the Turkish empire—a distrusted, powerless minority.

The situation became dire during World War I as the Turks embarked on a full-scale, extraordinarily brutal attack on the Armenian population. Gorky's family suffered incomprehensible horrors in a genocide that wiped out the Armenian population. In 1919, in the grips of a deadly famine that struck Armenia, Gorky's mother died of starvation.

Gorky had always enjoyed drawing, and his growing interest in art led him—like so many aspiring painters—to Greenwich Village. By the 1930s he had begun to accrue a measure of acclaim. By the 1940s he had developed a strikingly original style that had quite a bit of influence on his peers: thin paints with bright tints and washes; strokes of calligraphy-like black. "When … I walked into Arshile's studio for the first time," Willem de Kooning remembered, "the atmosphere was so beautiful that I got a little dizzy, and when I came to, I was bright enough to take the hint immediately…. I am glad that it is impossible to get away from his influence."

Gorky, perhaps not surprisingly, could be tough as nails. Verbally accosted by an inebriated, abusive Pollock, he casually extracted a long knife he used to sharpen pencils. The message was received.

The horrors of what Gorky had experienced in his youth never left him. There is an intrinsic subtlety to his paintings, with graceful, fluid lines that weave throughout much of his oeuvre. There is also a distinct foreign timbre to paintings such as *The Betrothal* (1947), with its Middle Eastern inflections. Betrothals, of course, invoke rituals and rites; in Gorky's personal history they surely connoted Armenian rituals and rites—which had been cruelly destroyed. Gorky's artistry, if one looked closely, had its disjointed elements.

The Artist and his Mother (ca. 1926–1936) is a haunting, immensely moving study of a little boy and his mother. Both are garbed in clothing

that is unmistakably foreign. The boy, wistful and delicate, is looking down. The mother stares out into the distance, her pupils wide and distorted, gazing off to some unknown point, unreachable. It is a stunning tableau of grief and loss.

Arshile Gorky, in person, was possessed of an Old World demeanor and cut quite the distinctive figure, often garbed in a flowing black cape. He was nicknamed the Picasso of Washington Square. The phrase Gorky would use to describe someone's discombobulation was "He has goats on his roof," the translation of an Armenian colloquialism. He was part and parcel of the thoroughly urban Abstract Expressionist milieu, but he grew to love the verdant countrysides of Virginia and Connecticut, evocative of his Armenian childhood.

Gorky's life was tragic on a scale of gothic proportions. In 1946 his studio was destroyed in a fire. He subsequently developed colon cancer. His marriage dissolved. And an automobile accident paralyzed his painting arm.

In this world there is no place for me.
—Arshile Gorky

That accident—traumatic enough for anyone, let alone an artist—plunged Gorky into a massive depression. The memories of his experiences during the war years, never extinguished, came back in full force. At some point he had written a poetic, mournful dirge in Armenian *In this world there is no place for me/They promise promise and do not fulfill their promises because of the myths.*

Arshile Gorky hanged himself in 1948, leaving behind a stark, chilling note: *Goodbye my Loves.*

My Murals for the Newark Airport: An Interpretation

The walls of the house were made of clay blocks, deprived of all detail, with a roof of rude timber.

It was here, in my childhood, that I witnessed, for the first time, that most poetic image for a calendar.

In this culture, the seasons manifested themselves, therefore there was no need, with the exception of the Lental period, for a formal calendar. The people, with the imagery of their extravagantly tender, almost innocently direct concept of Space and Time, conceived of the following:

In the ceiling was a round aperture to permit the emission of smoke. Over it was placed a wooden cross from which was suspended by a string an onion into which seven feathers had been plunged. As each Sunday elapsed, a feather was removed, thus denoting passage of Time.

As I have mentioned above, through these elevated objects, floating feather and onion, was revealed to me, for the first time, the marvel of making from the common the uncommon!

—Arshile Gorky 1936

To Arshile Gorky
by Peter Balakian

1

The sun hangs all day like summer

on my back. Chestnut leaves are fan-tails.

A rose against the hemlock is purple air.

Hummingbirds plume the fuchsia.

2

When I was a kid we had a garden

hanging with heavy things. Eggplants

almost black made shell scars in the mud.

Peppers and zucchini dragged along the furrows.

My mother pickled every cuke in the piss-colored

vinegar jars crammed with dill.

Ivy, moss, and grass were silver light at dusk.

3

The suckle falls like white water

on the side fence. In the wild-carrot

eggs are eyes; rabbits are knot-holes.

Tendrils loop like cut zither strings.

A raccoon hides in my stomach.

In the morning the milkweed comes.

4

Your mother is dried fruit in a dish.
Columbine is a flock of doves taking off.

5

Between a lake in Armenia and
my suburban house,
you're lamb bones in the ground—
chalk rising in the morning air.

Willem de Kooning

Jackson Pollock was the most visible face of Abstract Expressionism. Ultimately, though, it was his ally and rival Willem de Kooning who, in a decades-long career that waxed and waned, can probably be considered the paramount force of the movement.

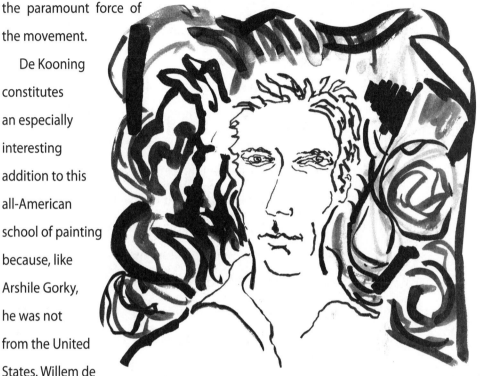

De Kooning constitutes an especially interesting addition to this all-American school of painting because, like Arshile Gorky, he was not from the United States. Willem de Kooning was Dutch, raised in the gritty port city of Rotterdam.

In 1926 he stowed away on a ship bound for America. As an undocumented alien, he followed the typical trajectory of a struggling painter: He found employment via the Federal Art Project, drew for *Harper's Bazaar* magazine, and executed a tobacco ad that graced the pages of *Life* magazine.

Many of the AbEx innovations were devised out of a combination of ingenuity and lack of cash flow. This was definitely true in de Kooning's case. Perpetually broke, he took to purchasing cheaper paint at a supply store that catered to sign painters. With this zinc white and commercial black

enamel paint, he was able to launch into an important series of black-and-white work. New York City, in all its manifestations, served as his inspiration. The writer Edwin Denby remembered a nighttime stroll with de Kooning during the 1930s, with the artist "pointing out to me on the pavement the dispersed compositions—spots and cracks and bits of wrappers and reflections of neon-light…" This was a new and different sort of tableau, and it was ubiquitous—found right on the street.

De Kooning's first one-man show, in April 1948, was a commercial bust, but it did bring favorable critical attention. His distinctive brushstrokes and commanding style began generating acclaim. He even managed, by the early 1950s, to purchase a new suit—his first in 20 years.

Pink Angels (1945) is considered the point at which a discernible de Kooning style began to emerge. The pulsing *Excavation* (1950), loosely inspired by the Italian neorealist film *Bitter Rice*, also attracted interest, but it was the sprawling, disturbing *Woman I* (1950–1952) and others like it that shook the art world. *Woman and Bicycle* (1952–1953), from the same series of grotesques, is inflected with garish, exaggeratedly "female" colors—green, yellow, beige—that suggest a 1950s beauty-product ad gone off the deep end. De Kooning's women were distorted and harshly rendered. There is more than a hint of misogyny.

After Jackson Pollock's death, Willem de Kooning began to assume the mantle of Abstract Expressionism's paramount painter. His downtown studio became a nexus for the art world. De Kooning was a Cedar Tavern regular (and heavy drinker). In a bit of uncomfortable symmetry, he was romantically involved for a time with Jackson Pollock's girlfriend Ruth Kligman, who had survived the fatal car accident. *Ruth's Zowie*, a de Kooning tour de force of 1957, is named after her. (If the title sounds suggestive, it isn't. *Zowie*—an

exclamation of high praise—is what Kligman supposedly uttered when she first saw the finished painting.) Like many of the Abstract Expressionists, de Kooning was hugely captivated by music, living long enough to be a fan of Talking Heads. He was famous for his verbal style, a Dutch-accented patois of his own making. Never doubting his own critical judgment, de Kooning was gutsy enough to openly admire Norman Rockwell.

Not surprisingly, de Kooning's paintings incorporated a deep unease. While he felt

The word "abstract" comes from the light-tower of the philosophers.

So the artist is always lighted up by it.

—Willem de Kooning

at home in the
United States, as a European he also felt
somewhat displaced.

His legal status was murky for years—he had, after all, arrived in the United States by hiding aboard a ship. De Kooning did not, luckily, suffer in the same way that Arshile Gorky had, but there were parallels. Despite being physically removed from the European continent, he was certainly acutely aware that the Netherlands had been overrun by Nazi Germany and that his home city of Rotterdam had been bombed into rubble.

Even de Kooning's more pastoral works have a dark underlay. *Door to the River* (1960) re-jiggers a chirpy schema of beige-pink and bold, expressive yellow. It's a color composition that would wonderfully augment the walls of a first-rate café, yet in de Kooning's hands there is more than meets the eye; something is not quite right. Even the poetic title is not entirely apropos: there are, after all, no literal doors that open to a river.

By the 1960s, Abstract Expressionism had faded as *the* sensation of the art world. De Kooning's reputation, not surprisingly, suffered accordingly. But by the time he died in 1997—in his nineties—his position in the first rank of American painters had been firmly secured.

What Abstract Art Means to Me

For me, only one point comes into my field of vision. This narrow, biased point gets very clear sometimes. I didn't invent it. It was already here. Everything that passes me I can see only a little of, but I am always looking. And I see an awful lot sometimes.

The word "abstract" comes from the light-tower of the philosophers.... So the artist is always lighted up by it.

...For the painter to come to the "abstract" or the "nothing," he needed many things. Those things were always things in life—a horse, a flower, a milkmaid, the light in a room through a window made of diamond shapes maybe, tables, chairs, and so forth. The painter, it is true, was not always completely free. The things were not always of his own choice, but because of that he often got some new ideas. Some painters liked to paint things already chosen by others, and after being abstract about them, were called Classicists. Others wanted to select the things themselves and, after being abstract about them, were called Romanticists. Of course, they got mixed up with one another a lot too.

—Willem de Kooning, 1951

Elaine de Kooning

Jackson Pollock and his spouse and fellow painter Lee Krasner were the go-to Abstract Expressionist couple. (Ultimately, of course, they were the *tragic* go-to couple of the art world.) Less vaunted, for some reason, was the twosome of Willem de Kooning and his wife, Elaine de Kooning.

The free-spirited Elaine Marie Catherine Fried, like many other like-minded artists, left the confines of her native Brooklyn for the wild, wider horizons of Manhattan bohemia. In 1943 she married a struggling immigrant painter named Willem de Kooning. It was a long, turbulent marriage—

and certainly not a marriage with any conventional notions of fidelity. She and her husband suffered through many lean years together in the hardscrabble, hand-to-mouth existence of struggling painters. She and de Kooning eventually separated in the 1950s, though the marriage was never legally dissolved.

Elaine de Kooning also faced the formidable challenges of being a female Abstract Expressionist in a hyper-male world. And, like Lee Krasner, she was inevitably overshadowed by her famous spouse. With determination and talent, however, de Kooning was able to carve out a niche of her own, gaining renown as a teacher and making significant contributions as a writer and critic. And she was possessed of a strong activist bent.

It was Elaine de Kooning's portraits that gained her painterly renown. Her subject matter, which tilted toward males, encompassed writers, artists, and critics such as Allen Ginsberg, Robert De Niro, Sr., and Harold Rosenberg.

She painted New York's young, marginalized Latino and black men; she painted the Brazilian soccer legend Pelé.

These images, said painter Fairfield Porter, were "both sympathetic and frighteningly acute." There was a subtle, yet crucial aspect to de Kooning's efforts: it was role reversal. The centuries-long practice, of course, had been for *men* to craft portraits and women to sit patiently until the work was done. A woman portraitist like Elaine de Kooning was not, to say the least, common at all. Nor were these static, typical depictions. Elaine de Kooning's portraits were crafted through the AbEx filter—swirling, atmospheric, unconventional. It was portraiture imbued with a sense of motion. Her rendering of poet Frank O'Hara, a pivotal force

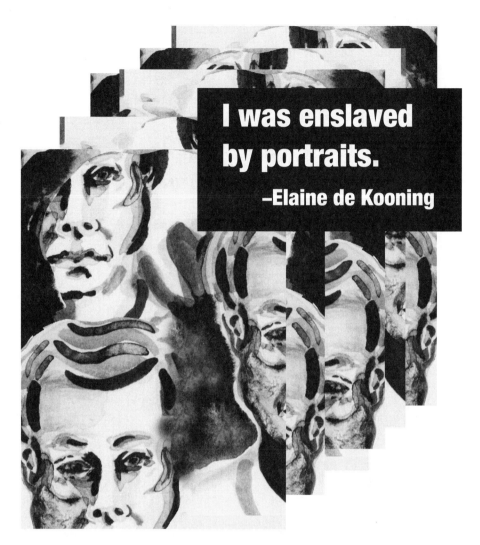

I was enslaved
by portraits.

–Elaine de Kooning

in Abstract Expressionism, has no face. This was not the standard mode of crafting portraits.

Her most famous endeavor was an extraordinary distinction: painting President John Kennedy. The idea of a presidential portrait undertaken by a representative of what was still considered a newfangled, slightly suspect school of art—and by a woman—was groundbreaking on several levels.

Elaine de Kooning died in 1989. She is one of the few representatives of Abstract Expressionism to occupy so many different slots: artist, teacher, writer, critic.

Painting a Portrait
of the President

President Kennedy was off in the distance, about twenty yards away, talking to reporters, when I first saw him.... He was incandescent, golden. And bigger than life. Not that he was taller than the men standing around; he just seemed to be in a different dimension. Also not revealed by the newspaper image were his incredible eyes with large violet irises half veiled by the jutting bone beneath the eyebrows....

I require absolute immobility of the sitter. This was impossible with President Kennedy because of his extreme restlessness: he read papers, talked on the phone, jotted down notes, crossed and uncrossed his legs, shifted from one arm of the chair to the other, always in action at rest. So I had to find a completely new approach

—Elaine de Kooning

Made in New York

New York City: Has any other American city had so many nicknames? The *Big Apple, Gotham, the city that never sleeps, Fun City*. As hackneyed as some of these appellations are (*the city so nice they named it twice* immediately comes to mind), they are indicative of New York's outsized role in the cultural history of the United States.

The AbEx story is also very much the story of New York City. If a person was artistically inclined, or unconventional, or a misfit, or an aspiring bohemian—or any combination thereof—New York was the logical destination. And Greenwich Village was the jewel in the bohemian crown.

> **Lower Manhattan was the place to be for aspiring painters.**

Lower Manhattan was the place to be for aspiring painters. The cheap cost of living made it a creative breeding ground. If you were willing to forego conventional notions of a comfortable life with regular meals and baths, it was very possible to carve out a space—metaphorically and literally—to paint or write or compose music. Creative types of every persuasion lived there, as did immigrants from around the world.

de Kooning's Studio
156 West 22nd Street

Barnett Newman's Apartment
343 East 19th Street

The Cedar Tavern
82 University Place

Helen Frankenthaler's Studio
East 10th Street

Waldorf Cafeteria
6th Avenue

The Club
39 East 8th Street

Leo Castelli Gallery
8 East 77th Street

Mark Rothko's Studio
157 East 69th Street

The Art of This Century Gallery
30 West 57th Street

Betty Parsons Gallery
15 East 57th Street

The Sydney Janis Gallery
110 West 57th Street

The Museum of Modern Art
11 West 53rd Street

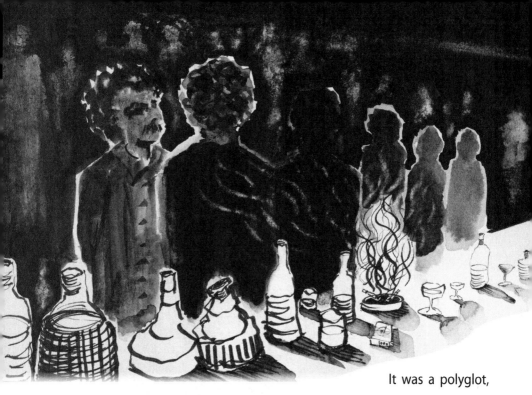

It was a polyglot, multicultural country all its own. In the 1930s Mark Rothko chanced upon a stranger on a Washington Square bench and fell into conversation: It was Willem de Kooning. Random, providential contacts of this nature were common in Greenwich Village at the time.

The painting life did take an enormous toll, with many of the Abstract Expressionists barely surviving as they hewed to their lonely vision. But if you could withstand the deprivation and the obscurity, an amazing life could be carved out of the concrete jungle.

The city had a network of greasy-spoon cafeterias where the customers could plunk down some change and spend hours nursing a cup of coffee or lingering over a piece of pie. And so here painters could find their way to meeting other painters: informal clubhouses on the cheap that predated the official Club in the late 1940s.

The cafeterias were a place for talking shop and cultivating friendships (and, no doubt, rivalries). They were ubiquitous, a city fixture so prevalent that they wove their way into New York folklore. (Many short stories by Isaac Bashevis Singer, for example, are set in these cafeterias.) "We were the cafeteria people," de Kooning would say. It was part and parcel of an inexpensive city that could support—and nurture—all sorts of artistic subcultures (most unlike the economic climate of New York City today).

When Abstract Expressionism eventually grew in prominence, its focal point could be found on Greenwich Village's University Place between Eighth and Ninth Streets. This was the locale of an utterly nondescript beer joint called the Cedar Tavern. During the 1950s, it became the iconic watering hole where many of the AbEx painters gathered night after night. The booze, dispensed by ex-Marine bartenders, flowed freely—very freely. Jackson Pollock was often on the premises—besotted, antagonistic, brawling. The Abstract Expressionists may have been irascible, but they certainly enjoyed boozing it up. The painters gathered at the Cedar Tavern, in the words of artist Budd Hopkins, for "sour, late-night bitching about dealers, collectors, and the art world in general."

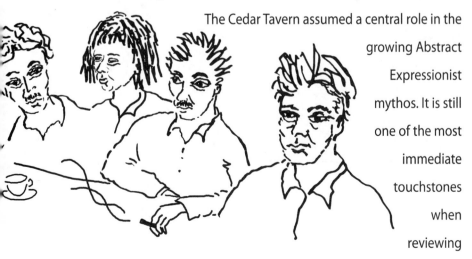

The Cedar Tavern assumed a central role in the growing Abstract Expressionist mythos. It is still one of the most immediate touchstones when reviewing

AbEx history, loosely akin to Max's Kansas City during the punk era of the 1970s. (The Cedar moved a few doors away in the 1960s and endured for a good four decades after. By then, though, it had lost its cachet.)

The city's very psyche became imprinted on these painters' output. New York was bold and limitless, a place of seemingly endless possibilities. The city swaggered. It represented rebirth with a special resonance for painters. It was the new Paris.

At the same time, of course, huge swaths of New York were poverty-stricken, rowdy, and dangerous. The city offered promise, but it also offered despair, harboring not just bohemians and free-thinkers, but every stripe of the disreputable. The streets were a good place to get your pockets picked; in later years they were a good place to get mugged. Abstract Expressionism was full of New York's cacophony and dissonance. The city overflowed with contradictions. It was the stuff of great art.

Recounting how the painter Milton Resnick challenged Pollock to "step outside" after the latter accused Resnick of being a "de Kooning imitator," Andy Warhol wrote: "I tried to imagine myself in a bar striding over to, say, Roy Lichtenstein and asking him to 'step outside' because I'd heard him insulting my soup cans. I mean, how corny."

—Lee Siegel, "Bye-Bye Bohemia"
(*New York Times,* May 17, 2013)

A Universe of
Disparate Intentions

"If you imagine an ordinary moment at an intersection in
New York City, a street light—some people are stopped and
others are in motion, some cars are stopped and others are in
motion—if you were to put that in film terms, in a freeze frame,
and hold everything for a second, you would realize that there's
a universe there of totally disparate intentions. Everybody going
about his or her business in the silence of their own minds with
everybody else, and the street, and the time of day, and the
architecture, and the quality of light, and the nature of the weather
as a kind of background or field for the individual consciousness.
When you think about that, that's what happens in the city,
in that somehow the city can embrace and accept and accommodate
all that disparate intention at one and the same time. Not only
in that corner, but in thousands of corners.
It's really an astonishing thing."

—*E.L. Doctorow*

Joan Mitchell

For all of Abstract Expressionism's distaste for conventional societal norms, the male painters hewed to timeworn notions about the status of women. That troglodyte attitude toward women was one of AbEx's least appealing qualities.

Female painters had a very, very uphill battle. They faced not just the myriad struggles that the male Abstract Expressionist painters had to deal with—which was difficult enough—but there was the added burden of crashing the AbEx boys' club. The lack of respect from the male painters was atrocious, and the problem was even greater than that. The wider art world, mirroring society at large, did its best to marginalize female artists. In the mid-1960s, *New York School: The First Generation* was published, an impressive study of Abstract Expressionism. The book, packed with artwork, critical essays, and extensive quotes from the painters themselves, contained not a single woman painter. Not one. This wasn't an isolated incident, not by any stretch. It was the norm.

Some women artists did break through the testosterone barrier. Often, as in the case with Joan Mitchell, they needed to be as rough-and-tumble as the men.

The blunt, no-nonsense (and, sadly, alcoholic) Mitchell had a surprisingly effete background. She was born into a well-to-do Chicago family in the

1920s. Her mother was a co-editor of the fabled *Poetry* magazine, and Mitchell grew up in rarefied artistic circles. She was quite the accomplished young athlete as well, a tennis player and champion figure-skater.

Art critic Peter Schjeldahl, writing in *The New Yorker*, recalled seeing Joan Mitchell's pugnaciousness on full display at a dinner party, writing of his "awe" at seeing "craziness of a scary and rare order. Those who knew Joan Mitchell" passed the horror stories "around like sacred-monster trading cards."

The paintings themselves of this second-generation Abstract Expressionist were of quite a different order. There was a wonderful vibrancy to be seen in much of Mitchell's work. Titles such as *Rose Cottage* (1953) and *Hudson River Day Line* (1955) indicate a deep, lyrical sensibility; her paintings also reveal a developed sense of humor, as in *George Went Swimming at Barnes Hole, but It Got Too Cold* (1957).

I am very much influenced by nature as you define it. However, I do not necessarily distinguish it from "man-made" nature—a city is as strange as a tree.

My paintings are titled after they are finished. I paint from remembered landscapes that I carry with me—and remembered feelings of them, which of course become transformed. I could certainly never mirror nature. I would like more to paint what it leaves me with.

All art is subjective, is it not?

—Joan Mitchell, 1958

Hemlock (1956) is instructive: a complicated, colorful kaleidoscope of prominent green swirls, touches of rust orange and a lush white; a thick, drippy execution. But the very title dispenses with the idea that this is solely an ode to nature. Hemlock, by definition, is a variety of poisonous herb, as well as a drug or lethal drink. It was hemlock, after all, which probably killed Socrates. There was no such thing, in the Mitchell worldview, as uncomplicated tranquility.

Mitchell eventually wearied of the New York art world and decamped for France, where she led the life of expatriate painter until her death in 1992.

"Her pictures become the windows she makes in her walls; they replace the walls," wrote Irving Sandler, a critic and contemporary. "The freedom in her work is quite controlled.... The characteristic gesture in Mitchell's painting is the swift, arcing, arms-long stroke that slices generously to the canvas edges, carving out huge spaces, or tiny ones that expand." During her lifetime, she never quite received her artistic due— a common fate for the female AbEx painters. Since her death, her posthumous reputation has continued to grow, finally garnering the attention it really deserved all along.

The East Village of the 1950s:
An Island Within An Island

"Go east of Avenue A when you move to New York," said artist
Joan Mitchell in the summer of 1955, when she encouraged me to
dare to leave Paris and come to live in New York City.

"Go to the Lower East Side. It still has that soulfulness you are
always talking about. Charlie Parker lived there. Artists like Franz
Kline, and so many others still do. It's the real New York. You'll find
it a haven from the Philistines. It's an island within an island."

When I came back home to the USA to live in New York, I
moved to my sixth-floor walk-up railroad flat apartment at 319
East Eighth Street (now torn down and rebuilt), between Avenues B
and C in the fall of 1955.

Joan Mitchell was right. The Lower East Side, now called the
East Village, was an island within
an island. There were still
a handful of old

men with pushcarts selling vegetables, pots and pans, used clothes and rags on the streets, and even a horse and wagon that was run by a man who claimed to be a gypsy prince who sharpened knives.

Yiddish, Spanish, Ukrainian, Russian, Romany, and Polish were so frequently spoken that most of the East Village's residents could say a few words in all the languages that filled the air. Their tapestry of sounds were accompanied by the delicious aroma of slowly simmering cabbage, blintzes, *shashlik, arroz con pollo, pierogi*, and clouds of various dishes using enormous amounts of garlic and fried onions.

In the spring, summer, and fall, the warm sense of community was celebrated with the sounds of radios blasting from the rooftops where people lay on blankets, drinking beer, creating a contrapuntal accompaniment to the sounds of accordion and fiddle players, playing folk songs from Central Europe, often backed up by bongo and conga players from the neighborhood who added the Latin rhythms of the *bomba* and *plena* from Puerto Rico and the *guaguanco* from Cuba, as well as improvising jazz artists occasionally joining in....

The East Village was now a place where we could ring the bells of freedom 24 hours a day, and we did.

—*composer and conductor David Amram*

Barnett Newman

In an artistic circle that teemed with all manner of outlandish behavior, Barnett Newman could be construed as a true eccentric—no small feat among the Abstract Expressionists. He sported a monocle tied to a black ribbon. He claimed to have shared the same tailor with Al Capone. In 1933, at age 28, he undertook a brief, oddball run for mayor of New York. But the affable exterior did not preclude a fighting—albeit, loopy—demeanor. In the 1950s Ad Reinhardt had castigated a new, less-than-desirable type of painter: the "avant-garde huckster-handicraftsman and educational-shop-keeper, the holy-roller-explainer-entertainer-in-residence," one of whom he

> **He often skipped school to play a sort of rarefied hooky by hanging out at the Metropolitan Museum of Art.**

identified as Barnett Newman. In a staggering overreaction, Newman sued Reinhardt for libel, asking for $100,000 in damages. Newman's case, not surprisingly, was found to be without legal merit.

Barnett Newman was born in New York City in 1905 and raised on the Lower East Side, that historic fulcrum of Jewish immigrant life. He often skipped school to play a sort of rarefied hooky by hanging out at the Metropolitan Museum of Art. Like a whole generation of poor immigrants' kids, he attended City College, majoring in philosophy. The Abstract Expressionists

did not, on the whole, put a premium on healthy relationships, but Newman was a happy rarity. His marriage to Annalee Greenhouse was long and supportive, an island of stability throughout the lean years, of which there were many. As late as 1955, Newman had only sold a handful of paintings, primarily to friends. He was forced to pawn some possessions and tried, he said, "to develop a winning scheme at the horse track."

I
Start
Each
Painting

As
If
I
Had
Never
Painted
Before

Barnett
Newman

Newman was particularly known for a painterly innovation that he dubbed "zips"—single-color rectangles interrupted by thin, vertical bands of contrasting colors. He was possessed of an understated sense of humor; his glib remark "Aesthetics is for the artists as ornithology is for the birds"

became part of AbEx folklore. But beneath the eccentricity and sometimes wisecracking public persona was a painter deeply immersed in the philosophy of Baruch Spinoza, Jewish mysticism, myth, and the unconscious.

Newman's utilization of monochromatic color forces the viewer—through the sheer power of the saturation—into a completely immersive experience. It's akin to melding into the painting's color schema. Although his artwork did not specifically reference political matters, he retained a pronounced leftist worldview. In 1968, for example, he publicly castigated the brutal treatment of Vietnam War protestors at the 1968 Democratic convention at the hands of Chicago police.

"What can a painter do?" Barnett Newman asked simply and directly. He did supply the answers, of course. They could be found by viewing his paintings. He also provided about as close to a painter's credo as was possible for Abstract Expressionism: "For me painting involved an immediate exercise of total commitment. It is what I am trying to say that is important. And I hope that I say it at once and in one moment."

The fact is, I am an intuitive painter, a direct painter. I have never worked from sketches, never planned a painting, never "thought out" a painting. I start each painting as if I had never painted before. I present no dogma, no system, no demonstrations. I have no formal solutions. I have no interest in the "finished" painting. I work only out of high passion.

—Barnett Newman, 1962

Grace Hartigan

Grace Hartigan is firmly slotted as a second-generation Abstract Expressionist. A native of New Jersey, she married at age 17 and left with her husband for the wilds of Alaska. They never made it and settled in California for a time. Inevitably they returned to New York.

Hartigan knew full well the steep odds of breaking into the estrogen-averse painting world and went to the extent of signing some of her early works as George Hartigan. She imbibed the poetry of Frank O'Hara and the paintings of Pollock and de Kooning, using them all as catalysts for her own creative explorations.

Hartigan was a diligent journal writer; the chronicle of her day-to-day life in the 1950s is an invaluable record of the struggles of an Abstract Expressionist painter. "Getting enough money for materials is a constant worry," she wrote in 1951.

"We could live on so little, if only a small income came from painting sales." One cold December, she related, her apartment was so frigid she actually painted in ski clothes. Not to be overlooked in her journal were self-exhortations—"Your color is getting too sweet!"—and a true AbEx credo: "I must not paint pictures which are comforting to my eyes." The pages are full of art-world observations, searing self-criticism, and a 1955 entry that fully encapsulated the roller-coaster existence these painters experienced over and over: "At last! Life is flooding me, I am filled with it—sure, excited.

Grace Hartigan

You start off with an idea

and then ideas keep coming as you're creating.

And eventually, the painting tells you what it wants.

Work until 8:00 PM, everything right so far. I can't even read now, just scrambled eggs, four highballs[!], smiling in the wing chair, schmaltz music & *early* to bed—alone of course."

There is a wonderful abundance of color to the paintings of Grace Hartigan. She also was one of the few AbEx painters (along with Larry Rivers) who fully embraced the colloquial, incorporating advertising, coloring books, and film into her artwork. Her oeuvre (again like that of Larry Rivers) was a real forerunner to the Pop Art that came after Abstract Expressionism.

In the early 1960s, Hartigan committed a shocking act: She upped and left New York City for Baltimore. While Baltimore had a significant literary and cultural history, the art world revolved totally and exclusively around New York City. She may just as well have been journeying again to Alaska.

She is known as a painter's painter...

Hartigan's resolve and independence enabled her, artistically speaking, to do essentially as she pleased. The move to Baltimore, though, did stunt her career. Always marching to the beat of a different drum, her work shifted into the figural—the antithesis of the abstraction so prevalent in the 1960s and 1970s. This, too, did little to enhance her reputation.

Grace Hartigan's renown and legacy are far, far from insubstantial. She is known as a painter's painter—not exactly unenviable. Yet the wave of feminist art scholarship that has brought welcome reevaluations of Lee Krasner, Helen Frankenthaler, and Joan Mitchell has not, as of yet, truly elevated Hartigan to the first ranks. "Somehow," she stated, "in painting I try to make some logic out of the world that has been given to me in chaos. I have a very pretentious idea that I want to make life, I want to make sense out of it. The fact that I am doomed to failure—that doesn't deter me in the least."

The arrival of Abstract Expressionism on the postwar art scene was big in every way: big canvases, big personalities, big publicity. It announced itself in no uncertain terms. For all the acclaim and sudden success, AbEx was also subject to an enormous amount of ridicule; a backlash. As soon as Jackson Pollock's art became known to the general public, he was tagged "Jack the Dripper."

> **Painting is the most ancient art...**
> —*Yoram Kaniuk*

On some level, this is the fate of any new, unconventional art form. Think of the endlessly derogatory jibes thrown at rock 'n' roll music during the 1950s and 1960s. The making of art, though, is primal in a way that other modes of expression simply are not. From almost the time a toddler learns to grasp, he or she is given crayons; as soon as it's feasible, the child works with paint. "Painting is the most ancient art," the Israeli artist and critic Yoram Kaniuk has written. "People painted in caves to drive out demons.... There weren't any words yet."

There *were* parallels. There is no doubt that James Joyce's *Ulysses* and other groundbreaking works of literature inspired the same kind of public scorn. And it didn't even have to be experimental writing: J.D. Salinger's *The Catcher*

in the Rye was widely stigmatized as "dirty." But books have a psychological and physical gatekeeper: a cover that has to be cracked open to peruse the writing inside. Painting, like singing, is perceived as everybody's business in a way that other media, like writing, simply are not. It is easy—too easy—to offer an initial assessment of a painting.

"My kid could do that" was an endless popular refrain voiced in reaction to Abstract Expressionism, a succinct encapsulation of the contempt that followed its rise.

J. Fred Muggs was a 1950s-era celebrity chimp, a regular fixture on *The Today Show*. In March 1958 he appeared on the cover of *Mad* magazine in a new guise: as an acclaimed painter. The cover also featured his "artwork." (It's interesting that Abstract Expressionism was deemed so odd, and yet the concept of a celebrity chimpanzee was widely accepted.) The chimp comparison, for some reason, struck a resonant chord. The poet and cultural critic Randall Jarrell wrote a supposedly humorous essay that recounted a television appearance by a painting chimpanzee named Jeff. "His painting, I confess, did not interest me; I had seen it too many times before," Jarrell explained. "What did it all produce?—nothing but that same old abstract expressionist painting…" The message wasn't subtle.

In one form or another, these tropes were rehashed endlessly. Indeed, they still are today. (And no, your kid—however talented—*cannot* make art like that! Thanks to modern science, that enduring canard was finally disproved. A 2011 study demonstrated conclusively that people can indeed distinguish between bona fide abstract art and art that has been created by children or animals.)

The fact that these painters were American and, at least theoretically, more accessible than their foreign counterparts, added another layer of

suspicion and contempt. Foreign artists, by the very fact that they were foreign, operated under their own set of indecipherable mores. They were *expected* to be eccentric. These brash new American painters, by contrast, gave the appearance of approachability. They could be—at least on the surface—deciphered. Pablo Picasso and Henri Matisse were off somewhere in a remote constellation. It was unlikely one was ever going to run into them. But Jackson Pollock and his gang were *not* foreign. They could be located with relative ease—perched on a bar stool, most likely.

And the Abstract Expressionists didn't necessarily like *you*. They didn't seem to give a damn if you "got" their paintings or not. In fact, some of the public suspected, their paintings were deliberately crafted to be as incomprehensible as possible. The onus was on you, the viewer, to make sense of them. The canvases were a test of your cultural IQ or hipness quotient. The general public, always on the lookout for a con, came to view these painters as nothing better than simple hucksters. President Harry Truman said their work looked like "scrambled eggs"—derision straight from the Leader of the Free World.

Jackson Pollock, with his primitive persona, did not help the cause of understanding. Indeed, intentionally or not, he added to the misconceptions. It certainly *looked* as if all he was doing was standing astride a

canvas, flinging paint every which way. And it certainly *looked* as if Ad Reinhardt was simply adding black paint to a canvas—like painting a wall—and then sitting back to receive critical accolades. "You want to know how to create a real genuine masterpiece?" an editorial writer asked rhetorically in 1959. "It's easy. Get a pot of paint—any old kind—and a brush, and then have a 'ball' on canvas."

Abstract Expressionism got it from all sides.

"Art never seems to make me peaceful or pure," Willem de Kooning asserted. "I always seem to be wrapped in the melodrama of vulgarity. I do not think of … art in general … as a situation of comfort." And there it was: a loud, bold declaration of vulgarity and anti-comfort. Even the more vulgar rock 'n' rollers who emerged in the mid-1950s at least *pretended* they weren't cretins.

Abstract Expressionism got it from all sides. The rarefied *New Yorker*, whose sophisticated readership reasonably could be expected to look kindly upon this new form of artistic expression, lampooned it mercilessly, finding a common ground with *Mad* magazine in its contempt. A typical *New Yorker* cartoon from 1955 depicts a scruffy, beatnik-type painter in his hovel. In an unexpected bit of proto-feminism, his put-upon female partner labors at the kitchen sink. With evident satisfaction, the man is looking over his artistic creation: nothing more than basic geometric patterns. "There!" he exclaims. "A message of good will for all mankind!"

In an episode of *The Dick Van Dyke Show* titled "Draw Me a Pear," protagonist Rob Petrie—the very model of suburban propriety—ventures outside his comfort zone into the alien land of Greenwich Village to take art lessons from a female painter. The young bohemian teacher has some highly unconventional, suggestive ideas about what constitutes art instruction.

(What she envisions is as mild as mild can be—she touches Rob's face to draw his features—yet this was considered ribald for 1960s television.) The Village female painter, here, is the ultimate outlier, unencumbered by accepted societal norms—unmarried, full of kooky ideas about art, bordering on indecent.

The Abstract Expressionists were creating something very new. Much of what they created did, in fact, require decoding on the part of the viewer. But cultural introspection was not exactly a prized commodity during the conformist 1950s (if it *ever* has been a prized commodity in the United States). And then there was the pervasive suspicion of artists of all stripes that was ingrained in American society. Writers and poets were seen as high-blown drunks, musicians as disreputable, painters as construing all sorts of inflated rationalizations to work with nude models. Lucy, Ricky, Fred, and Ethel truly enjoyed their European sojourns. But, as in one episode, they were conned into purchasing bogus original paintings that proved to be mass-produced duplicates.

The irony, in the long run, is that AbEx has laughed its way to the bank, derision and all. The stereotype of the scruffy painter in his bare-bones hovel—like that *New Yorker* cartoon—eventually became as passé as traveling salesmen jokes. Today Abstract Expressionist paintings are auctioned off for tens of millions of dollars. The outsiders became the establishment.

Modern Art Shackled to Communism

"As I have previously stated, art is considered a weapon of communism, and the Communist doctrinaire names the artist as a solder of the revolution. It is a weapon in the hands of a soldier in the revolution against our form of government, and against any government or system other than communism....

The Communist art that has infiltrated our cultural front is not the Communist art in Russia today—one is the weapon of destruction, and the other is the medium of controlled propaganda. Communist art outside Russia is to destroy the enemy, and we are the enemy of Communism....The art of the isms, the weapon of the Russian Revolution, is the art which has been transplanted to America, and today, having infiltrated and saturated many of our art centers, threatens to overawe, override and overpower the fine art of our tradition and inheritance. So-called modern or contemporary art in our own beloved country contains all the isms of depravity, decadence, and destruction.

What are these isms that are the very foundation of so-called modern art? I call the roll of infamy without claim that my list is all-inclusive: dadaism, futurism, constructionism, suprematism, cubism, expressionism, surrealism, and abstractionism. All these isms are of foreign origin, and truly should have no place in American art."

—*Congressman George Dondero, 1949*

Art Goes Undercover

If the Abstract Expressionists suffered unending mockery
at the hands of the general public and even *The New Yorker*, they
found a wellspring of support from some very unlikely allies: the
U.S. government and the CIA. And that had everything to do with
the topsy-turvy American political climate of the 1950s.

AbEx was very much affected by the prevailing streams in
American society: the fear, the repression, the conformity. And yet it
also blossomed, thanks to the new, postwar prosperity.

As the political establishment relentlessly informed the public,
America was in a life-and-death battle with the Soviet Union.
The Communist giant, official sources said, was a grave threat to
everything Americans held dear. The United States needed to be
Sparta: strong, brave, tough; ready to take on the Soviets in a battle
for the very survival of the planet. This new American Sparta needed
more than just well-prepared soldiers. It needed sound minds,
world-class education, and cutting-edge scientific innovation. To
meet those needs, massive amounts of money were spent on new
universities and research facilities. It was an astonishing paradox
that so much expansiveness came from so many ugly reasons.
The state university systems, for example, are a product of the
Eisenhower 1950s.

The battle was equally urgent in terms of shaping global
opinion—winning over hearts and minds on an international

scale. The Soviet Union was extolling the virtues of *its* society at every opportunity, swaying not just average citizens around the world—which was bad enough—but striking deep chords among governmental officials, intellectuals, and creative types everywhere. The United States girded for battle.

In a series of odd collusions among various branches of the federal government—the State Department, the United States Information Agency, and the Smithsonian Institution—diverse examples of American culture were shipped abroad. The Boston Symphony Orchestra, for example, toured Europe in 1952 with funding from an unnamed governmental agency: none other than the Central Intelligence Agency. There was no better way to show how truly and absolutely free American society was than with a display of its unfettered, unrestrained works of creative expression in all fields. Static art that reflected a static society was emblematic of the Soviet Union, not the United States.

Jazz traveled abroad, as did musical theater, dance—and art. Abstract Expressionism was deemed a pivotal physical representation of a free, sophisticated society. A society *couldn't* be repressive if it allowed this kind of art—and not just *allowed* it, but held it up for international inspection. And so the works of Pollock, Motherwell, Rothko, and de Kooning were sent abroad, with CIA backing, in a sort of triumphal tour.

Among other things, this gave full meaning to the adage that politics makes strange bedfellows. The irony that a gang of disreputable, alcohol-guzzling painters—many of whom were

distinctly left-wing in their politics—
were chosen to embody the virtues of
American society certainly did not go
unnoticed. Some lawmakers, unaware of
the intent behind this sudden interest
in art appreciation, thought the State
Department had lost its mind.

In contrast to Harry Truman, who seems to have been a
sourpuss when it came to modern art (he of the "scrambled eggs"
comment), President Dwight Eisenhower was in full, enthusiastic
accord with the idea of art as a propaganda tool. And the CIA,
still in its early years, included a preponderance of upper-class Ivy
League types. When not subverting democracy around the world,
many CIA staffers loved art. Utilizing AbEx for their own purposes
was really not a stretch. Indeed, the collusion also went straight
to the heart of the art establishment: the head of the Museum
of Modern Art in the 1940s and 1950s was Nelson Rockefeller,
future governor of New York, three-time presidential candidate,
and fervent anti-Communist.

Abstract Expressionism has had its detractors on political
grounds alone. Some dislike it for its Cold War symbolism, which
is understandable. But inherent in that criticism is a strange,
perverse compliment: AbEx was art so powerful that it could,
some felt, actually help sway public opinion away from the Soviet
Union and toward the United States. The scrambled eggs had
come a long, weird way.

Helen Frankenthaler

Helen Frankenthaler was born in New York City in 1928. She was a student at the prestigious Dalton prep school in Manhattan and graduated from Vermont's Bennington College, after which she studied with Hans Hofmann. While steeped in the AbEx orientation, Frankenthaler also absorbed inspiration from European painters, taking in the influence of Joan Miró and Henri Matisse.

The approach of this second-generation Abstract Expressionist was distinct and iconoclastic. She circumvented the more typical AbEx brushstroke techniques—a "special courage," as poet and art critic James Schuyler wrote, which involved "going against the think-tough and paint-tough grain" of the Abstract Expressionist ethos.

Much of Frankenthaler's work joined painting and drawing with a distinctive, personal calligraphy. There is a wonderful lyricism and combination of colors in her work, such as the pinks and blues

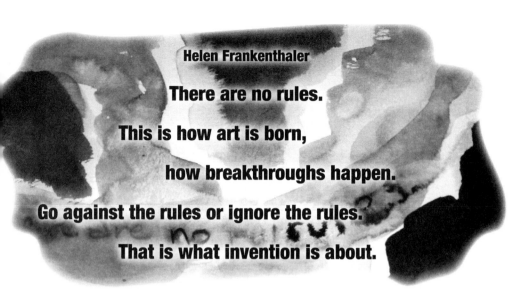

Helen Frankenthaler

There are no rules.

This is how art is born,

how breakthroughs happen.

Go against the rules or ignore the rules.

That is what invention is about.

of her acclaimed *Mountains and Sea* (1952). Her work morphed away from AbEx and into what became known as Color Field. Steadfastly refusing to be pigeonholed, Frankenthaler also undertook etchings, lithographs, woodcuts, and illustrated books. She was married for a time to fellow painter Robert Motherwell, setting up shop in Connecticut after her divorce in the 1970s.

Frankenthaler, too, labored under the constraints of female painters, her recognition lagging behind that of male counterparts. "Looking at my paintings as if they were painted by a woman is superficial," she said in something of an understatement, "a side issue…. The making of serious painting is difficult and complicated for all serious painters. One must be oneself, whatever."

"I had… a great desire to see the world," Frankenthaler also stated, to "travel and move about." This is supremely evident in her body of work.

Helen Frankenthaler died in 2011. Her art-world significance has undergone a welcome, steady reappraisal—a process of correcting, at least in some measure, Abstract Expressionism's sexist legacy.

Philip Guston

"There are so many things in the world … so much to see," Philip Guston wrote. "Does art need to represent this variety and contribute to its proliferation? Can art be that free? The difficulties begin when you understand what it is that the soul will not permit the hand to make."

He was born in Montreal, Canada, in 1913—another product of a Russian-Jewish family fleeing from violent, deep-rooted anti-Semitism. It was a family evidently unable to outrun its own demons, as Guston's father committed suicide. (Suicide seemed to be a horrible undercurrent to Abstract Expressionism: Guston's father and two AbEx painters—Arshile Gorky and Mark Rothko—terminated their own lives. And Jackson Pollock's crazed dissipation might be interpreted as a sort of gradual suicide.)

The Guston family moved to Los Angeles in 1919. Jackson Pollock was a high-school friend of Philip. The two were expelled together for circulating an inflammatory broadside, and they remained artistic allies as well as rivals. (Guston's first solo show, in 1945, entailed a post-exhibition dinner party that was ruined

by a drunk and belligerent Pollock.) Largely self-taught as an artist, Guston found work as a movie extra as a young man in the 1930s. He also worked in a factory and drove a truck. Like so many of his peers, he came of age during the Great Depression and embraced activist art; his first work of public art was deemed so politically inflammatory that it incurred the wrath of far-right vigilantes. He, too, was one of the

There are
so many things
in the world...
so much
to see.

–Philip Guston

many painters to work for the Federal Art Project; his art could be seen on an outdoor wall of the WPA building at the historic 1939 New York World's Fair.

Early on, Guston had cartooning aspirations. His interests were nothing if not eclectic. Along with an understandable enthusiasm for such comic strips as *Barney Google, Mutt and Jeff,* and *Krazy Kat*, he was deeply affected by the writings of Franz Kafka, Nikolai Gogol, and Isaac Babel. He was also a friend of the avant-garde composer John Cage. With such an array of influences, it is not surprising that some of his later work took on a notoriously oddball

quality. It was postulated during the 1960s that he was under the sway of *Zap*, R. Crumb's infamous underground comic. (Guston denied the influence.)

Interestingly, Guston was the subject of a *Life* magazine profile in 1946, a good three years before Jackson Pollock's celebrated appearance in that magazine—but not generating nearly the same amount of attention. It was not until 1951, with the showing of *Red Painting*, that he really achieved prominence in the art world.

Somewhat atypically in the Abstract Expressionist realm, Guston's work contained large elements of political imagery. The Ku Klux Klan, in various guises, was a running theme in many of his paintings. His work was assertive and bold and he was not afraid, at times, to be funny. There was also an intensely lyrical side—a shimmering, dreamlike quality—to his canvases.

Philip Guston, with his deep-running political passions, was much more deeply affected by the tumult of the 1960s than most of his AbEx peers. He was, in his own words, "feeling split, schizophrenic. The war, what was happening to America, the brutality of the world." In 1971, partly inspired by the novel *Our Gang*, his friend Philip Roth's lethal takedown of the Nixon White House, Guston commenced a series of scathing anti-Nixon drawings.

Passionate and political art-making was not, in Guston's case, synonymous with a warm personality. "He was the arch crank," composer Morton Feldman related. "Very little pleased him. Very little satisfied him. Very little was art."

Guston had long maintained a presence in the artistic enclave of Woodstock, New York. His star dimmed, however, and he became increasingly isolated there in a sort of self-imposed exile from the New York City art scene. "I couldn't go to New York, to openings of friends of mine like Rothko, de Kooning, Newman," his daughter, Musa Mayer, quoted him as saying. "I would telephone Western Union with all kinds of lies, such as that my teeth were falling out, or that I was sick. It was such a relief not to have anything to do with modern art."

Guston died in Woodstock in 1980. His distaste for the world of modern art was not reciprocal, with a posthumous reputation as a groundbreaking, genre-busting creative force. "Human consciousness moves, but it is not a leap," Guston wrote, "it is one inch. One inch is a small jump, but that jump is everything. You go way out and then you have to come back—to see if you can move that inch."

I expect other people to look at painting the way I look at painting, just as painting. My work must be demanding for a spectator, but what can I do? I think there's some law at work—an invisible law—that means you can only accept certain things at a certain time—so that if you're working to please yourself or catering to yourself, why should you cater to a looker or art critic? Why should you meet their expectations? If I destroy my own expectations, why should I worry about others' expectations?

—Philip Guston, 1965

On the Humanity of Abstract Painting

"An abstract painter entering a room where a mathematician
has demonstrated a theorem on the blackboard is charmed by
the diagrams and formulas. He scarcely understands what they
represent; the correctness or falsity of the argument doesn't concern
him. But the geometrical figures and writing in white on black
appeal to him as surprising forms—they issue from an individual
hand and announce in their sureness and flow the elation of
advancing thought. For the mathematician his diagram is merely
a practical aid, an illustration of concepts; it doesn't matter to him
whether it is done in white or yellow chalk, whether the lines are
thick or thin, perfectly smooth or broken, whether the
whole is large or small, at the side or center of the board—
all that is accidental and the meaning would be the same
if the diagram were upside down or drawn by another
hand. But for the artist, it is precisely these qualities that count;
small changes in the inflection of a line would produce as
significant an effect for his eye as the change in a phrase in
the statement of a theorem would produce in the logical
argument of its proof."

—art historian Meyer Schapiro, 1960

Franz Kline

The garrulous Franz Kline, by unofficial consensus, was the nicest, most approachable of the Abstract Expressionist painters. He was raised light-years away from anything approaching an artistic enclave, a product of Wilkes-Barre, Pennsylvania's coal-mining country. His upbringing was almost shockingly mainstream: a varsity high-school football player, captain of the team. Kline had an interest in cartooning and drew for his high-

school

paper. He studied

art in England in the 1930s and subsequently found work as a caricature artist in Greenwich Village.

The cash-poor Kline, like Willem de Kooning, was forced to utilize inexpensive house paint for his fine art. Also like de Kooning, he grew to enjoy that déclassé medium. As per the AbEx practice of incorporating

The final test of a painting, theirs, mine, any other, is:

Does the painter's emotion come across?

Franz Kline

unconventional modes into his artwork, Franz Kline worked not only with house paint but also with house-painting brushes.

Kline executed stark, distinctive black-and-white works, which subsequently had an effect on minimalist painters. To achieve his desired effects, he often painted at night under intense artificial light. It has been postulated that his stripped-down output references the sooty, stark landscape of Pennsylvania's steel mills and coal mines: terrain that doesn't inspire a lush color palette. *You scared of color? Scared of Line?* wrote Dwight Ripley in his poem "An Alphabetical Guide to Modern Art." *Then concentrate on Mr. Kline.*

> **Kline executed stark, distinctive black-and-white works, which subsequently had an effect on minimalist painters.**

One of Abstract Expressionism's particular strengths is that it gives life to the time-honored adage *There's more than meets the eye.* At first glance, Franz Kline's work can appear to be absolutely primal. *Mahoning* (1956) consists of bold, slashing black forms

on a white background. But the black—as in the work of Ad Reinhardt—is not entirely monochromatic. And upon further inspection, the white background has blots and whispers of gray. All is not as it appears.

Kline, too, was caught up in the vortex of tragedy that haunted the Abstract Expressionists. His wife was institutionalized for more than a decade. He was hard-drinking and afflicted with rheumatic fever. He suffered heart attacks. And in 1962, just short of his fifty-second birthday, he died suddenly, cutting short a career that presumably had much more to offer the world. "The final test of a painting," Franz Kline had said, "theirs, mine, any other, is: Does the painter's emotion come across? By that measure, Kline passed the test.

It is nice to paint a happy picture after a sad one. I think that there is a kind of loneliness in a lot of them which I don't think about as the fact that I'm lonely and therefore I paint lonely pictures, but I like kind of lonely things anyway; so if the forms express that to me, there is a certain excitement that I have about that. Any composition—you know; the overall reality of that does have something to do with it; the impending forms of something. do maybe have a brooding quality. whereas in other forms, they would be called or considered happier.

—Franz Kline, 1963

Richard Pousette-Dart

Fame—as opposed to artistic renown—is a funny, fickle thing. Richard Pousette-Dart has enormous significance in the AbEx body of work, and his paintings certainly won critical acclaim. His art-world fame, though, is another story, with a career trajectory somewhat similar to Grace Haritgan's. It was fine, of course, to march to a different drummer, but not *too* different. Abstract Expressionism, which called for the tearing down of arcane artistic strictures, ironically had strictures of its very own.

> **Abstract Expressionism, which called for the tearing down of arcane artistic strictures, ironically had strictures of its very own.**

Richard Pousette-Dart, in contrast to his more bombastic painting peers, was quiet and self-effacing. In the early 1950s, just as AbEx was rearing its head, he left New York City to live and paint in rural New York State. His work oscillated between various styles, eventually moving away from Abstract Expressionism and into his own unique, almost eccentric, mode. For these reasons, he has never really received his full due.

This is especially ironic because Pousette-Dart was there at the very inception of Abstract Expressionism. He exhibited in Peggy Guggenheim's Art of This Century gallery and posed with the 17 other Irascibles in *Life* magazine.

> **He produced art that anticipated what Jackson Pollock did.**

Richard Pousette-Dart was born in St. Louis in 1916, the son of a painter and art-writer father and poet mother; he was raised in New York State's Westchester County. It must have been an unconventional household. His father, Nathaniel Pousette, and his mother, Flora Dart, merged their last names in a gesture of equality, decades before the practice came into vogue during the 1960s and 1970s. After a short stint at Bard College in upstate New York, Pousette-Dart made his way to New York City and established his reputation as an artist in his mid-twenties. (Financial success did not really come until the 1960s—a very, very long wait.)

Lacking formal art training and the youngest of the AbEx bunch, Pousette-Dart was nonetheless the painter who first began showing on large canvases. This is of no small significance. His work was not only in lockstep with that of fellow Abstract Expressionists; he produced art that anticipated what Jackson Pollock did. And his interests were admirably far-reaching:

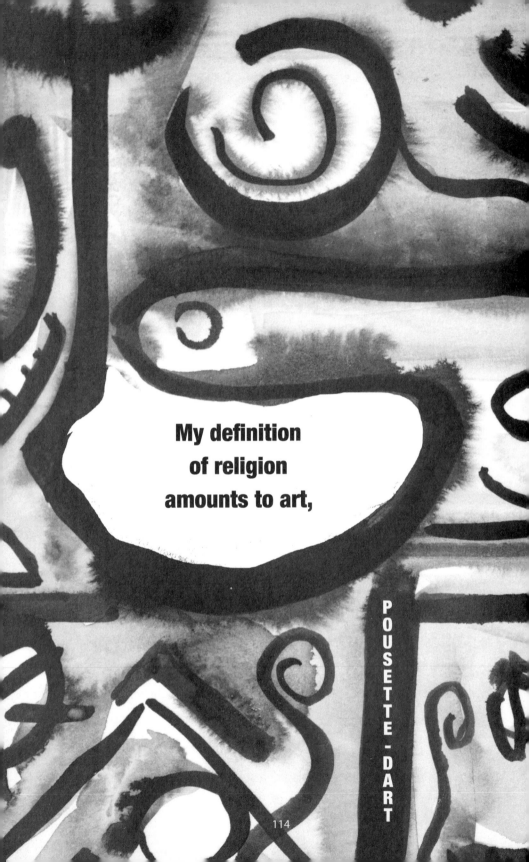

My definition
of religion
amounts to art,

POUSETTE-DART

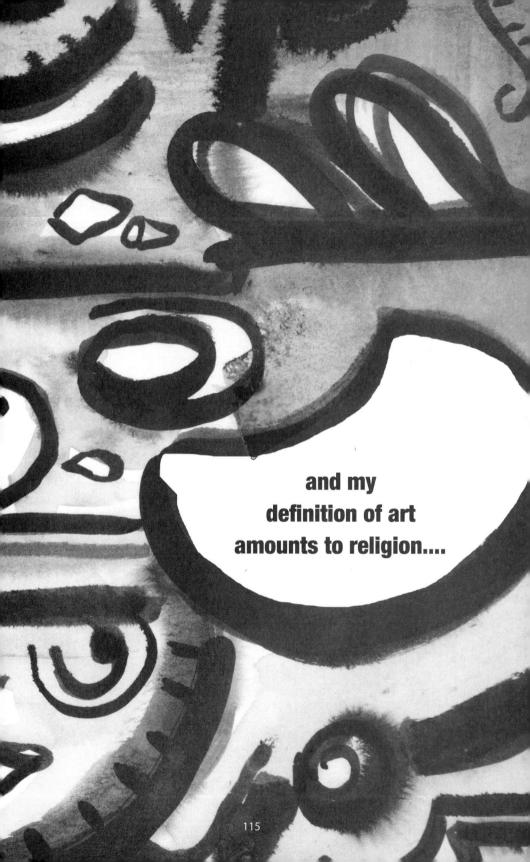

and my
definition of art
amounts to religion....

115

"Art is always mystical in its final meaning"

African and Native American art, calligraphy, psychoanalytic theory, and amateur radio. He also demonstrated a fascination with other media, including wire sculpture and photography.

"My definition of religion amounts to art," Pousette-Dart declared, "and my definition of art amounts to religion…. Art is always mystical in its final meaning … it is life of the soul…. The artist is the only moral man because he alone overcomes fear and has the courage to create his own soul and to live by means of the light in it."

The fiercely solitary Pousette-Dart has been deemed, in the words of *New York Times* art critic Roberta Smith, the "patron saint of American painting's wide-ranging visionaries and eccentrics"—an ambiguous distinction. His personal demeanor was leagues away from the usual AbEx lot. In later years, he was a bearded, soft-spoken man, unafraid to declare openly—idealistically—that creative people had the power to save the world.

Not surprisingly, there is a hallucinatory, mystical aspect to his output: complicated, intricate, and swirling, in layer after layer of

paint. As in the work of Arshile Gorky, there is a strong, redolent hint of something foreign, of different shores. And like Larry Rivers, there is most certainly a proto-sixties, trippy feel to much of his output—all the more astonishing when one considers that some of this work, such as *Fugue No. 2*, dates from the 1940s.

Richard Pousette-Dart wandered away from what was construed as truly Abstract Expressionism. That was probably a large issue in terms of his reputation: his artwork morphed into so many different, eclectic forms that it was hard to get a feel for the Pousette-Dart oeuvre. (Curiously, the Pousette-Dart name has another, unexpected association: His son, Jon, fronted the Pousette-Dart Band during the 1970s.)

There are, then, a whole array of reasons why Richard Pousette-Dart did not join the first tier of Abstract Expressionist renown, though the reasons are ultimately flimsy. "Art transcends, transforms nature, creates a nature beyond nature, a supra nature, a thing in itself—its own nature, answering the deep need of man's imaginative and aesthetic being," he had written. A rediscovery is long overdue.

I'm against all war, and I'm against fighting, or killing for any purpose whatsoever.... I think the real creative human being—maybe he's an artist, maybe he's something else—but the person who realizes wholeness in himself is the real soldier. He is fighting on the front lines of creative imagination or creativity—he'll die for that. But he won't die killing other people.

—Richard Pousette-Dart, 1986

In Living Color

Color Field was a stream of modern art that arose in the Abstract Expressionist era during the 1950s. It was partly a response to Abstract Expressionism and partly an offshoot of it. Much of Color Field stemmed from the creative mind of Helen Frankenthaler. She was, of course, a bright light in the AbEx firmament, heavily influenced by Jackson Pollock. Her artistic trajectory, though, diverged from Pollock's. "I wanted to work with shapes in a very different way," she recalled. "And instead of being involved in his technique, what evolved for me out of my needs and invention had to do with pouring paint, and staining paint." There was a very immediate technical manifestation to what Frankenthaler had in mind, which involved diluting her paint to the extent that it became thin enough to melt into the canvas's weave. The paint became the canvas; the canvas became the painting. Her *Mountains and Sea* (1952) has been construed by some as the kickoff to Color Field.

Color Field could be interlinked with Abstract Expressionism in many ways. Besides Frankenthaler, Mark Rothko, Clyfford Still, and Barnett Newman—Abstract Expressionists all—made significant excursions into Color Field. The flatness of the canvas, Abstract Expressionist gospel, was also part and parcel of Color Field, as was the commitment to abstraction. It was saturated color simply for its own sake. It was also a school of painting that worked large— similar again to Abstract Expressionism. Color Field paintings were an immersive experience.

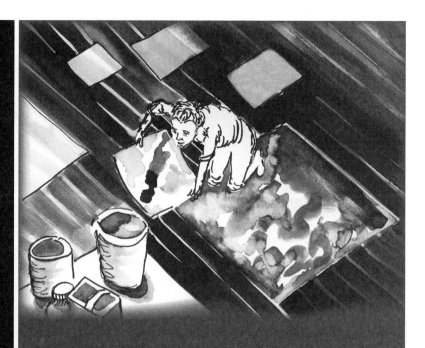

At the same time, Color Field painting was a response to Abstract Expressionism: an approach in a different direction. Morris Louis, a leading Color Field painter, recognized Helen Frankenthaler as "a bridge between Pollock and what was possible." The Color Field painters, while certainly indebted to Abstract Expressionism, wanted to go their own way. Color Field, for one, was a deliberate shift away from Abstract Expressionism's heavy drama and love of the gestural. Abstract Expressionism didn't necessarily view color itself as a prime factor. Color Field, as its name implied, definitely did.

Color Field was beautiful, restrained, less impulsive. It was Abstract Expressionism's more polite first cousin.

Clyfford Still

Clyfford Still was Richard Pousette-Dart's direct counterpart in solitary, removed-from-the-crowd art-making. Still's go-it-aloneness matched Pousette-Dart's, but where Pousette-Dart tilted toward the mystical and contemplative, Still carved out a rarefied, fiercely independent ethos that was equally fierce in its contempt of art-world commerce, commercialization, and any perceived ethical deviations from society at large.

Still was born in Grandin, North Dakota, in 1904, and there was a flinty, prairie-like aspect to his demeanor. His pivotal paintings, accordingly, are jagged, harsh, and brooding. Even the titles themselves are stark, almost

industrial: *1947-J, 1947-K, 1950-H. No. 1.* A man of the West, he taught at Washington State University and—to drive home the point that he was cut from finer, more erudite cloth than your run-of-the-mill painter—care was taken to inform that "His faculty friends were rarely other art teachers, but members of the music, English, philosophy, and mathematics departments…." For a painter, Clyfford Still could seem weirdly like the small-town banker who denies your loan and then delivers a lecture on financial responsibility. He dedicated one series of his paintings "To all those who would know the meaning and the responsibilities of freedom." He viewed the art environs of New York City as essentially hostile terrain.

That aside, Clyfford Still was an Abstract Expressionist of the first order—an artist in every way, closely attuned to art's spiritual, ennobling side. "By 1941," he later recounted, "space and the figure in my canvases had been resolved into a total psychic entity, freeing me from my limitations of each, yet fusing into an instrument bounded only by the limits of my energy and intuition. My feeling of freedom was now absolute and infinitely exhilarating…."

Still finally settled in Maryland in 1961, turning his back for good on the New York scene. He died in 1980, but the tale didn't end there. He had held on to some 90 percent of his artistic output, totaling more than 2,000

pieces. Their combined value, had they been released into the commercial world, was estimated at $1 *billion*. His terse, one-page will stipulated that his artwork be given to a city that pledged to house it in a museum that contained *only* the works of Clyfford Still. There were the Irascibles, and then there was Clyfford Still. He was in a category all his own.

The artist's wish came to fruition in 2011 with the opening of the Clyfford Still Museum in Denver. And it is a most deserved memorial, the magnificent—unique—repository of a hugely significant painter.

An Open Letter to an Art Critic

Riffling through some old magazines a few days ago, an article by you in a 1959 *Evergreen Review* stopped me abruptly. For as you must remember, it dealt with the art dealers and galleries in New York, with special emphasis on the importance of their walls to the artists during the 1940s and 1950s, and the alleged role they played for the artist and public then and now. The issues ... are mainly a record of fantasy rather than fact, and shameless hypocrisy wrapped in saccharine words of dedication.... It is unfortunate to your discredit that yours was one of the first articles to initiate this sordid parade of falsification and apology.

—Clyfford Still, 1963

Roadshow Treasure

For the uninitiated, PBS's TV show *Antiques Roadshow* is a sort of traveling antiques carnival. A crew of appraisers arrives in a city and evaluates all manner of peoples' heirlooms, gee-gaws, furniture, and attic or basement detritus. The viewing pleasure comes from learning what these objects are, where they come from, and who made them. *Antiques Roadshow* also delivers the promise of a payday, or not. Some of the objects are worthless, some worth a small amount. And some—a very few—are worth a fortune.

In a setting that undoubtedly would have horrified Clyfford Still on every conceivable level, a 2009 episode from Palm Springs, California, featured a woman seeking an appraisal for a long-ago housewarming present: a 1937 painting of the construction of the Grand Coulee Dam in Washington State. The painting happened to be by Clyfford Still, well before his work evolved into Abstract Expressionism. To the woman's absolute shock, the piece was valued at half-a-million dollars, making it one of *Antiques Roadshow*'s biggest jackpots.

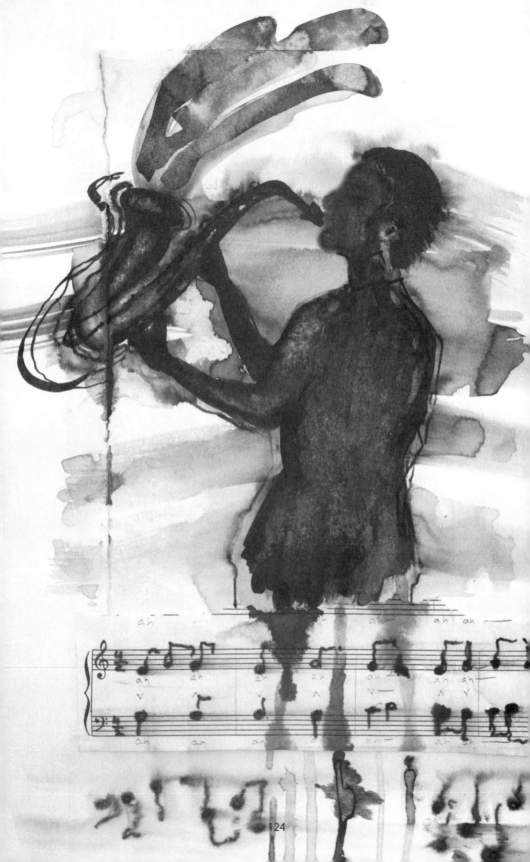

At the same time that a bold, newfangled school of painting was taking root in postwar New York, a similar phenomenon was transpiring in jazz. The interchange between music and painting is a time-honored constant. And those links have, if anything, grown stronger in the modernist era: George Gershwin painted, as did Miles Davis and Ornette Coleman. Joni Mitchell paints, and the core of the 1960s British rock 'n rollers went to art school. There's obviously a real connectivity between the creative impulse that paints and the creative impulse that plays music.

In the case of Abstract Expressionism and bebop/modern jazz, the parallels are striking and out of the ordinary; the two forms are forever linked. Both emerged at roughly the same

era, and both emerged in the same city. The cross-pollination in each camp was also similar: A cluster of like-minded painters prowling the city, learning and taking from each other (and rejecting from each other, too), while, at jazz club after jazz club on Fifty-second Street, musicians could

play, jam, and borrow from each other in similar fashion. On a given night, artist and musician Larry Rivers remembered, "you could hear Billie Holiday at the Onyx, Charlie Parker and Dizzy Gillespie at the Deuces, Coleman Hawkins at Kelly's Stable."

Yet as much as the birth of both artistic movements can be explained, they also, to an extent, *can't* be explained. There are similarities in the emergence of AbEx and jazz that defy analysis, akin to spontaneous combustion. It just so happened that these particular musicians and these particular painters gathered in New York City at this particular time and created these particular movements. There are lots of reasons why this happened, but it's also a mysterious concoction, doomed to a lack of concise definition. There was never again such a cluster of painters, never again such a grouping of jazz musicians. This didn't mean that painting and jazz stopped progressing—quite the contrary. But the concentrated nature of both these streams never happened again in art or jazz.

Both AbEx and jazz responded to similar stimuli: New York City and American society at large after World Word II and into the 1950s. Jazz, improvisational by nature, had a verve and wit that was very much in keeping with the spirit of New York City—just as so many Abstract Expressionist canvases captured the spirit of postwar urban life.

Abstract Expressionism can be said to have provided a visual interpretation of those conflicted, fractured times, while jazz provided an aural interpretation. At sometimes the two merged: Jackson Pollock's *White Light* (1954) graces the cover of the classic, pivotal Ornette Coleman album *Free Jazz* (1961).

Jazz was the go-to music for bohemians, left-wingers, and artist-types. It occupied an outsized slot in the culture of the times: the soundtrack to

the Beat movement. Writers like Jack Kerouac and Allen Ginsberg explicitly linked their writing to a jazz feeling and similar methods of improvisation. William Burroughs's novel *Naked Lunch* (1959) was created in a deliberately random fashion that mirrored jazz and also took its lead from the Abstract Expressionists. His own writing, Burroughs asserted, "treats words as the painter treats his paint, raw material with rules and reasons of its own."

"A writer is merely an artist with antennae tuned into certain cosmic wavelengths," Burroughs went on. "They're attuned to the film—that's what life is, a film—and they bring part of it back in a form people can understand. A painter does largely the same thing."

> Abstract Expressionism can be said to have provided a visual interpretation of those conflicted, fractured times, while jazz provided an aural interpretation.

Jazz was also the protest music of its day. It was mostly black, it was mostly urban, and it often carried with it the strong air of disrepute: late nights and marijuana. Maynard G. Krebs, the stereotypical uber-beatnik in the late-1950s-early 1960s teen sitcom *The Many Loves of Dobie Gillis* really dug jazz—more, he said, than he even dug girls. Jazz could be shorthand for a lot of things, sometimes all mixed together: beatniks-painters-reprobates.

To add further to the mix, many of the jazz-loving Beat writers—including Ginsberg, Gregory Corso, and Lawrence Ferlinghetti—also painted. William Burroughs was a serious painter, although his methods, not surprisingly, were highly unconventional (at some point incorporating mushrooms and firing a shotgun at a can of paint for maximum splatter

effect). Novelist Jack Kerouac, like some of the Abstract Expressionists, was interested in cartooning at an early age and he, too, painted. The author of *On the Road* was not, actually, a huge fan of abstract art, although he was friendly with Larry Rivers, Franz Kline, and Willem de Kooning. His writing, so very jazz-based, was also modeled on painting.

> **The Abstract Expressionist painters were constructing arresting, sometimes harsh artwork because they were observing a harsh society.**

A great deal of the affinity was simply visceral: The painters loved jazz. Even the venerable French painter Henri Matisse—the last person on earth, perhaps, to be found diggin' the music of Dizzy Gillespie at some smoky midtown club—was inspired to do a series of collages titled, simply, *Jazz*. Jackson Pollock, according to his wife and fellow painter Lee Krasner, "would get into grooves of listening to his jazz records ... day and night for three days running, until you thought you would climb the roof....

He thought it was the only other really creative thing that was happening in this country."

Abstract Expressionism dispensed with accepted notions of what painting was supposed to be—it left nothing out, jagged edges and all—and postwar jazz was part of the same ethos. Charlie Parker, Dizzy Gillespie, Miles Davis, et al were intent on creating music that served as the polar opposite of those smooth, big-band ensembles cranking out danceable tunes as the waiter brought your champagne. There was no way in hell to dance to Charlie Parker, and that was the point. It was like asking Jackson Pollock to paint scenes of barns and silos.

There was also the implicit social commentary embedded in both. Abstract Expressionism could—and did—deal with the topical, just as in jazz. (As the 1960s gathered steam, some jazz did get very political.) But that wasn't the intent. The societal commentary was more by inference. The Abstract Expressionist painters were constructing arresting, sometimes harsh artwork because they were observing a harsh society. The AbEx canvases could contain bright and bouncy colors, and they could be infused with cheery elements, but the Abstract Expressionists were not interested in "cheery." (The mere mention of it would probably get a drink tossed at you at the Cedar Tavern.) Likewise, jazz had much in the way of beauty and delicacy, but there was a lot of concentrated misery in the music of Charlie Parker and others.

To be a jazz musician was to take a blood oath. It was a calling, a way of life, with its own language and mode of dress. You ate and breathed jazz: John Coltrane practiced his saxophone so much that he bled. The Abstract Expressionists operated with similar dedication and bravado. Painting was joining a select order and involved total immersion, whether in marathon sessions at one's studio or late nights at the Cedar Tavern. Sadly, such dedication and bravado often involved—in both camps—a credo of widespread dissipation. That was the tragedy that haunted musicians

and painters. Charlie Parker died in 1955, Jackson Pollock in 1956: two tragic bookends.

The Abstract Expressionists saw themselves as classic outsiders and felt an enormous affinity for these jazz musicians, another constellation of fellow outcasts. There was, however, a crucial difference. The vast majority of jazz musicians were African American, who had no real choice in the option of being outsiders or not. It was a status thrust upon them by virtue of skin color. The Abstract Expressionists, to a large extent, basically chose their outsider status. It was an option for them in a way that didn't exist in jazz culture. The painters, at least, had the option of pulling back, becoming "respectable"—or at least giving it a try. Jazz musicians—regardless of talent, fame, or nice clothes—couldn't order lunch in the greasiest of greasy spoons in huge swaths of the country. The Abstract Expressionists never faced Jim Crow.

> **The vast majority of jazz musicians were African American, who had no real choice in the option of being outsiders or not.**

Shading, tonality, texture: These were the essential elements of both Abstract Expressionism and the new vistas in jazz. Miles Davis recorded an album titled *Sketches of Spain* (1960); "Self-Portrait in Three Colors" is not the name of a painting, but a composition by Charles Mingus. Jazz was crucially free-floating, but also had structure and discipline. The improvisational nature of the music could follow a very distinct pattern: melody, improvisation, melody. The Abstract Expressionists were crafting abstract art, but there was a discipline and precision to what they were doing as well; there were rules.

Jazz was a medium that constantly rejiggered the classic American songbook: standard after standard was appropriated by these musicians and reconstituted into something new and astonishing. If one followed the artistic dictum of *make it new*, the perfect example was to be found in jazz. In 1961 John Coltrane made a famous recording of the Rodgers and Hammerstein standard "My Favorite Things," a song more associated, of course, with Julie Andrews in *The Sound of Music*. Coltrane's radically different version found its voice on the soprano saxophone. His version of "My Favorite Things" was long and sinewy and had Middle Eastern undertones; at times it sounded like a lament. The Abstract Expressionists, in similar fashion, took the equivalent of a venerable standard—American painting—and tossed it around. They may have used some pleasing elements, but they were using them in a very new, very different way.

Abstract Expressionism, so gestural and definitive, brought the individual to the fore. There was no mistaking the overwhelming personalities that had created these paintings. Modern jazz also—in a big, historic way—brought the individual musician to the fore. Big bands had a certain anonymity. Unless you were the actual bandleader or an attention-grabbing virtuoso, the individual musician did not really assume a front-and-center role. But there was no mistaking the individuality of sound in modern jazz. Charlie Parker's alto-saxophone technique could come from no other alto saxophone. Max Roach's drumming could never in a million years be construed as a simple exercise in timekeeping for a swing band. The individual modern-jazz musician played in a definite, personal, *individual* way, the polar opposite of indistinguishable ensemble music. John Coltrane's saxophone can be ascertained in the first three seconds of a song.

In the late 1950s, poet and artist Jonathan Williams wrote that the "only

solace for a poet in New York is the occasional spirit in painting and jazz…. [T]his spirit radiates for me from the paintings of de Kooning … and from the sessions of Charles Mingus." And so the painting of Willem de Kooning and the jazz of Charles Mingus were explicitly linked. Those comparisons and those links, of course, went well beyond de Kooning and Mingus. They were there for all to see, for all to hear.

Ornette Coleman on the Art of Jackson Pollock

They look like signals or messages, like a letter he's writing in the form of art, like some advanced Braille. It's not something that you've seen before that you can name. It's something that he created as he did it. The act of creation is the creation.

—*New York Observer*, 2006

Taking a mushroom, a toadstool, sticking it in color and using it as a paintbrush. I hate the limitation that says, "You can only do it with a brush." I say, "What's this shit?" There's so many ways: spattering, marbling, strips of paper, rollers. Pollock's drip can device, the Rorschach method… all these randomizing techniques. I got some good mileage out of them mushrooms.

—William S. Burroughs

Lee Krasner

Lee Krasner suffered from a unique double-edged sword that served as real detriments for her career and posthumous reputation. There was, first, the large burden female painters had to carry. On top of that, Krasner was also Jackson Pollock's spouse, ministering angel, and de-facto manager. She was hidden under a very large shadow.

The acerbic, verbal Krasner was born and raised in New York City, another child of Jewish refugees who had fled from the anti-Semitism of Eastern Europe. She underwent rigorous art studies, both at New York City's prestigious Cooper Union and subsequently at the National Academy of Design. Krasner took on a variety of duties for the WPA's Federal Art Project during the 1930s and was a pupil of Hans Hofmann. He paid her the supposedly supreme compliment of saying that her artwork was so good one couldn't ascertain that a woman had painted it. Such were the times.

Krasner was all too aware of Abstract Expressionism's endless, pernicious sexism. "There were the artists and then there were the 'dames'" she later recounted. "I was considered a 'dame' even if I was a painter too."

Krasner and Pollock became a couple during the 1940s. They certainly made an odd pairing: the wild man of the West and the Jewish immigrants' daughter. However improbable the two of them were, they made a formidable team, with Krasner occupying a multifaceted role—even, in those bare-bones early years, of conducting business via the Waldorf Cafeteria pay phone—that pushed Pollock into art-world prominence.

> **Lee Krasner's own art, to her credit, is difficult to pigeonhole.**

That Lee Krasner subsumed her own career in favor of the massively self-destructive Jackson Pollock is without dispute. It's also the eternal puzzle—Why did she do it? It certainly did no favor to her reputation. The standard narrative was that Krasner unambiguously sacrificed her own career for Pollock's. The real narrative, though, is a bit more nuanced than previously thought. It was Krasner who ushered Pollock into the artistic

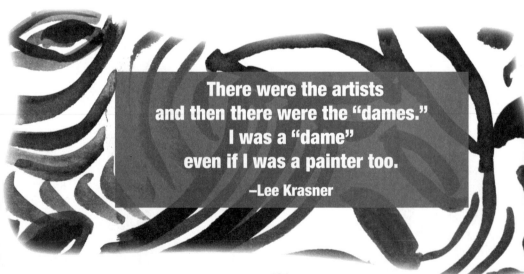

> **There were the artists and then there were the "dames." I was a "dame" even if I was a painter too.**
>
> —Lee Krasner

milieu of Greenwich Village, not the other way around. The Pollock-Krasner relationship, moreover, was also more symbiotic than commonly assumed: Pollock, in many cases, learned from Krasner. Nor did she entirely cease painting during the stormy years of their marriage.

Lee Krasner's own art, to her credit, is difficult to pigeonhole. Her output was AbEx through-and-through, imbued with that love of gestural painting. There was also a distinct European sensibility to her artwork as well. She was a virtuoso of color and line, unafraid to wander into diverse media that encompassed collage and mosaic.

The Seasons (1957), with its unadorned and self-explanatory title, is instructive. She painted it after Pollock's death, filling the canvas with a circular, sweeping swirl of reds and greens: colors associated with the cycles of the year—and the cycle of life. There is also a slightly gaudy color composition to the work that—ever so subtly—keeps it from being solely a painterly rumination on the changing calendar. There is a feeling of disquiet, of something not right. Grief and trauma are in the air, hovering in the background. *The Seasons,* Krasner related, was a response to the question of "whether one could continue painting at all, and I guess this was my answer."

The comment, if anything, was understated. Krasner's artistic answer—to keep on painting—was emphatic and long-lasting. The rise of the women's movement and feminist scholarship spurred on a welcome reevaluation of many of the Abstract Expressionist women whose reputations had been so ignored. Around 1970 Lee Krasner began receiving her critical due as a pivotal talent very much in her own right.

When one starts using the unconscious as a source to take off it doesn't mean that it's an unconscious painting because the consciousness is there. The artist is there. You're aware. The point at which you stop or pick up or make your next move is a conscious move....And I'm not interested in a prior theory when I paint my picture, because I think you get an awful lot of dead painting. not interesting. dead, sterile. Well, that's not very exciting. for heaven's sakes. One wants to discover.

—Lee Krasner

Mark Rothko

Marcus Rothkovich was born in 1903 in the province of Vitebsk, then a region of the mammoth Russian empire (now a region of Belarus). His family was part of the vast Jewish exodus from the czar's domain, and Rothkovich—eventually taking the name Mark Rothko—arrived in the United States at the age of ten. The family settled in Portland, Oregon. Soon, with the father's sudden death, the immigrant family had to cope with more than the usual rigors of feeling at home in a new country.

Young Rothko had engineering aspirations, as seen decades later in his precise, controlled artwork. He attended WASPy, upper-crust Yale University on a scholarship, but it was not a happy college experience and he dropped out. Rothko eventually moved to New York City, where he lived in tenements, worked in the déclassé garment industry, and later found employment in the WPA.

Rothko's career as an artist progressed to the point that, in 1945, he merited a one-man show with Peggy Guggenheim. His painting is often characterized by restraint and precision, while at the same time it is deeply emotional—a delicate and subtle perch to occupy. His striking innovations in color and space also had application in the Color Field school. By intent, his works should be seen up close, making the viewer an active participant.

A picture lives by companionship,

expanding and quickening

in the eyes of the sensitive observer.

—Mark Rothko

The "rabbi of Abstract Expressionism," as he was called, achieved greater and greater success during the 1950s and 1960s. Rothko's art garnered the entirely dubious distinction of being lauded by *Fortune* magazine in 1954 as a promising investment. His dining habits shifted from pastrami sandwiches at the deli to more exotic fare at fancy Chinese restaurants. His painting studio was originally located in the grubby environs of the Bowery, but by the 1960s he was painting in a converted carriage house on the tony Upper East Side—perhaps rubbing shoulders with the same snobby elite he had faced at Yale decades before. He achieved sufficient renown to warrant (along with Franz Kline) an invitation to John Kennedy's 1961 presidential inauguration.

Mark Rothko was not one of the Cedar Tavern's regular carousers, but he had a tortured psyche that involved plenty of dissipation. He began many

of his days with a stiff shot of vodka, chain smoked, and suffered from depression and hypertension. A hypochondriac, he medicated himself with a toxic regimen of valium, booze, and a plethora of pills for sundry ailments. Not surprisingly, he was an extraordinarily difficult person to deal with, hypersensitive to the people he sold his work to. One had to be worthy to own

> The "rabbi of Abstract Expressionism," as he was called, achieved greater and greater success...

a Mark Rothko. (Frederick, the snobbish, prickly painter in Woody Allen's *Hannah and Her Sisters*, comes to mind. Played by Max von Sydow, Frederick emphatically turns down a potentially lucrative sale to a well-meaning—but cloddish—rock star, whose sole criterion for good art is if it's big or not.)

Rothko's mental slide continued on its terrible downward trajectory and came to a horrific conclusion with his suicide in 1970. He was not even granted the benefit of a peaceful legacy, as his daughter became embroiled in a ferocious legal battle over the disbursement of his estate.

The painter Hedda Sterne perfectly expressed the bewilderment and sorrow at the tragic denouement and end of an artistic force: "Who was this man, Mark Rothko, who killed my friend?"

Maybe you have noticed two characteristics exist in my paintings; either their surfaces are expansive and push outward in all directions, or their surfaces contract and rush inward in all directions. Between these two poles you can find everything I want to say.

—Mark Rothko, 1953

Robert Motherwell

Robert Motherwell, the son of a banker, was born in Washington State in 1915. The fact that he was a banker's son is not completely tangential. The relatively privileged background and rarefied tastes set him apart from the other, more rough-hewn and less affluent Abstract Expressionist painters.

He was married for a time to fellow painter Helen Frankenthaler, forming a sort of upscale art-world power couple, setting up house on Manhattan's Upper East Side in a comfortable lifestyle that was duly noticed in the greater painting community. The antithesis of the Abstract Expressionist hell-raiser, he was eventually awarded the National Medal of Arts in 1989.

> The antithesis of the Abstract Expressionist hell-raiser, he was eventually awarded the National Medal of Arts in 1989.

Motherwell also occupied a unique niche as a writer and theorist, befitting someone who had done graduate work in philosophy at Harvard and had studied with the art theorist Meyer Schapiro at Columbia. In the 1960s, under the aegis of Viking Press, he edited the collected writings of such vitally important painters as Picasso, Duchamp, Mondrian, and his AbEx comrade-in-arms, Ad Reinhardt.

For all these differences, Robert Motherwell was possessed of the same steely, go-it-alone Abstract Expressionist ethos. "A modern painter," he wrote, "may have many audiences or one or none. He paints in relation to none of them.... [A]nd if the modern painter should have a relation with any audience, it is because that audience had somehow found *him*...."

He, too, was fearless when it came to wandering into other media, such as collage and printmaking. And he had no illusions in his political and social

worldview. To Motherwell, anxiety and violence were an intrinsic part of the American psyche. *View from a High Tower* (1944–1945) is a collage that utilized—of all things—a military contour map. *Dublin 1916, with Black and Tan* (1964)—inspired by the poetry of William Butler Yeats—references the Easter Rising in Ireland and the fight for independence from Great Britain. His seminal creation, perhaps, was the *Elegy to the Spanish Republic* series, more than 100 paintings completed between 1948

> **All my life I've been working on the work— every canvas a sentence or paragraph of it.**
>
> —Robert Motherwell

and 1967. With its primal references to life and death, the series is a lament for Spain's doomed egalitarian republic, crushed by the armies of Francisco Franco during the 1930s. Monsters, too, make up an unexpected sub-theme in the Motherwell oeuvre, evoking "the monstrous ambiguity of an artist's situation."

Motherwell's output blended both the deliberate and the free-flowing, which reflected his polyglot interests: poetry, calligraphy, and—as appropriate for an ardent Francophile—the writings of Marcel Proust, André Gide, Albert Camus, and Charles Baudelaire. *The Homely Protestant* (1948) takes its title from the Surrealist practice of picking up a book,

sticking a finger in it, and extracting a random line. Motherwell tried this with James Joyce's novel *Finnegans Wake*, and the phrase *the homely protestant* was what came up:" [M]y finger rested on the words *'the homely protestant,'* and I thought, 'Of course, it is a self-portrait.'"

> **Motherwell's output blended both the deliberate and the free-flowing...**

Motherwell was deeply, passionately connected to the Mediterranean. *The French Line* (1960) is an evocative rendering in orange and sea blue, with the interjection of a tropical, Sunkist-orange color schema that's both playful and strikingly unexpected. Motherwell appropriated butcher paper for his art; he incorporated the logo of the French publisher Gallimard, wine labels, train tickets, and a host of other ingredients for his

collage work. There is joy and exoticism to the art of Robert Motherwell, but there is also an acute awareness of war and misery. This, to say the least, requires some precision balancing.

"All my life I've been working on the work—every canvas a sentence or paragraph of it," Motherwell wrote. "Each picture is only an approximation of what you want. That's the beauty of being an artist; you can never make the absolute statement, but the desire to do so as an approximation keeps you going."

In the Random House Unabridged Dictionary, there are eighty-two entries under the word "open." For me those entries are one of the most beautiful poems in modern English, filled with all kinds of associations, all kinds of examples.

—Robert Motherwell, 1976

The Abstract Expressionists were, to be sure, the insurgents of the art world. For all their sometimes noble-savage posturing, however, AbEx was undergirded by a serious artistic ethos, as well as a crucial foundation of critical gravitas. While the painters painted, others spread the word and Abstract Expressionism found its way into the greater culture at large, as well as the community of intellectuals, theorists, and academics.

The poets were the proselytizers. If the very real commonalities between jazz and Abstract Expressionism could veer slightly toward the metaphoric (seeing a painting and going to hear jazz in a smoky club in some ways *weren't* entirely similar), the poetry-painting fusion was no stretch at all. Postwar poetry really mirrored Abstract Expressionism—poets also had their New York School, just as the painters did. The literary world was in the vanguard of breaking down one artistic stricture after another. The ones who took that directive to heart were the postwar poets.

Frank O'Hara was the central poet associated with Abstract Expressionism. As a 1950 Harvard graduate, his classmates included diplomat Henry Kissinger, author

George Plimpton, and illustrator Edward Gorey. His first book of poems, *A City Winter, and Other Poems* (1952) was actually published by Tibor de Nagy Gallery—a primary venue for the Abstract Expressionists and not, obviously, a conventional publishing house. In New York, O'Hara occupied a dual role as poet and art-world personage, joining the staff of *Art News* and then assuming various curatorial positions with the Museum of Modern Art. Much of his poetic output was, not surprisingly, art related: "Walking with Larry Rivers" (*Praying perhaps for rain and a chess partner*); "Poem Read at Joan Mitchell's";

> **Frank O'Hara was the central poet associated with Abstract Expressionism.**

"Ode to Willem de Kooning" (*while our days tumble and rant through Gotham and the Easter narrows*); "On Rachmaninoff's Birthday & About Arshile Gorky." He shared the AbEx love of alcohol and was that rare non-painter who was admitted into the Cedar Tavern contingent—a "charming madman." O'Hara

was openly gay in an era that didn't take too kindly to the out and proud; he was also romantically involved with painter Larry Rivers. (One of his poems is titled "Homosexuality.") Tragically, he came to an especially hideous end: While walking along the beach at night, he was struck by a dune buggy and killed. Frank O'Hara occupies a unique position, weaving and overlapping in and out of the Abstract Expressionist world.

Fast Company:
The World of Frank O'Hara

"He had already made an auspicious start as a poet. After nursing a failing novel through his first months of studying creative writing at the University of Michigan, he junked it, wrote ninety poems and two plays, and won a prize. If you write ninety poems in the course of a few months, you probably mean something different by the word 'poem' from what most people mean. O'Hara didn't introspect or recollect much. His poems lacked the formal appliqué of rhyme and meter, and, where most poets deposited words with an eyedropper, O'Hara sprayed them through a fire hose. He had entered Harvard on the G.I. Bill, at a time when overflow freshmen slept on cots in the gym, but soon he and his roommate, the artist Edward Gorey, established their rooms as (in the words of a home-town friend) the spot to 'lie down on a chaise longue, get mellow with a few drinks, and listen to Marlene Dietrich records.' When he wasn't reclining on the chaise, he picked fights about books and music. His crooked nose, broken in his youth, suggested the pugilism he brought to aesthetic disputes."

—Dan Chiasson, *The New Yorker*, April 7, 2008

There was much in the way of critical thinking and theorizing as Abstract Expressionism came to the fore—and it came to the fore, among many reasons, *because* of the critical thinking and theorizing. In essence, the critical movers and shakers of AbEx can be distilled into two primary theorists: Clement Greenberg and Harold Rosenberg. The two vied for supremacy as the art-world's primary intellectual. Each had his own circle, his own advocates, and his own favorite painters. The Greenberg-Rosenberg rivalry was as intense as any between the painters themselves.

Clement Greenberg

Clement Greenberg—the "pope of modernism"—originally intended to carve out his cultural niche as a literary, not art, critic. The literary field, though, was a crowded one. Serious writing about the new strains of American painting that were beginning to make themselves felt offered more in the way of possibility. With a mixture of genuine interest and shrewd careerism, Greenberg shifted gears to focus on art, becoming *The Nation*'s art critic in 1942.

> **Greenberg's critical support helped advance Pollock's career...**

Clement Greenberg provided the erudite narrative that complemented the Abstract Expressionists. Referencing a cast of characters that included Karl Marx and Immanuel Kant, Greenberg slotted Abstract Expressionism as part of a rarefied lineage that stretched back to Édouard Manet and Paul Cézanne. Painting, to Greenberg, was separate and discrete from other art forms—the most potent refutation of the mass-production and stifling conformity of American society. Abstract Expressionism was a higher calling.

He was a fervent apostle of Jackson Pollock—in the words of Tom Wolfe, the "curator, custodian, brass polisher, and repairman" of Pollock's reputation. It was another variant of Pollock and Krasner's odd, symbiotic relationship, this one between a highfalutin Marxist critic and the barbarian of the art world. It was a sort of leapfrog: Greenberg's critical support helped advance Pollock's career; Pollock's prominence enhanced Greenberg's status as Abstract Expressionism's aesthetic guru. (Conflict of

interest, apparently, was a concept that had not fully reached the art world. Eventually, though, the mutually advantageous relationship did rupture.)

Clement Greenberg's actual feelings toward the painters themselves were surprisingly caustic. "As stupid as a painter" was a favorite Greenberg epithet. He was prone to scathing observations: "To be an artist is to be pompous. Painters are less cultivated than writers and therefore pretentious in ways writers know enough to avoid." He viewed the goings-on at the Cedar Tavern with disfavor, accurately gauging the pernicious influence it had on painters. (And perhaps there was another reason Greenberg was less than enamored with the place. One evening at the tavern, he became engaged in a passionate discussion on painting with Willem de Kooning— a discussion that ended with de Kooning threatening to punch him.)

> Clement Greenberg, for all his many flaws, was pivotal in putting Abstract Expressionism on the map.

Greenberg provided vital scholarship, but he was also fond of bold, declamatory statements in the vein of self-proclaimed oracle, such as: "Let painting confine itself to the disposition pure and simple of color and line, and not intrigue us by association with things we can express more authentically elsewhere." Not surprisingly, he attracted his fair share of detractors: "a mediocrity with an education," said one. To Philip Guston, Greenberg was "a mixture of unlearned art historian, semi-Marxist, and box-score keeper."

Clement Greenberg, for all his many flaws, was pivotal in putting Abstract Expressionism on the map. He helped supply it with a cultural and intellectual overlay.

Harold Rosenberg

Greenberg was not the only game in town. The other central critic and polemicist was his rival, Harold Rosenberg. Rosenberg's seminal essay, "The American Action Painters," ran in the December 1952 issue of *ARTnews* and spotlighted him as a critic to be reckoned with. Action painting, in Rosenberg's eyes, took on the form of the painter engaging the canvas as if it were an arena—an arena for expressing one's individuality. This view helped to shift the emphasis away from analyzing the completed picture to putting more weight on the painter's process. "The painter no longer approached his easel with an image in his mind," Rosenberg wrote. "He went up to it with material in his hand to do something to that other piece of material in front of him."

> **The animus between Harold Rosenberg and Clement Greenberg ran deep.**

Like Greenberg, Rosenberg was heavily influenced by Marxist theory, but his writing also owed much to Jean-Paul Sartre and Existentialism. Rosenberg had the odd, posthumous distinction of appearing—albeit in fictionalized form—in the Saul Bellow short story "What Kind of Day Did You Have?" (a story about a world-famous critic and his mistress.) Rosenberg's writing was also noted for an admirable, erudite sense of humor: "People carry their landscapes with them," he wrote, "the way travelers used to cart along their porcelain chamber pots. The stronger their sense of form the more reluctant they are to part with either."

The animus between Harold Rosenberg and Clement Greenberg ran deep. Both agreed that Abstract Expressionism was the avenue to a higher, rarefied culture, but they had widely divergent ideas about theory and doctrine. Like many rivalries, theirs was also a plain, old-fashioned turf battle over popularity and influence. Rosenberg achieved an extraordinary pulpit, becoming art critic for *The New Yorker* in 1967, a position he held until his death in 1978. "The big moment came when it was decided to paint ... just TO PAINT," Rosenberg wrote. "The gesture on the canvas was a gesture of liberation...." That is certainly one of the most succinct encapsulations of Abstract Expressionism's rise and triumph.

"The big moment came when it was decided to paint... just TO PAINT. The gesture on the canvas was a gesture of liberation...."
–Harold Rosenberg

When they started out, the "abstract expressionists" had had the traditional diffidence of American artists. They were very much aware of the provincial fate lurking all around them. This country had not yet made a single contribution to the mainstream of painting or sculpture. What united the "abstract expressionists" more than anything else was their resolve to break out of this situation.... The general impression is still that an art of high distinction has as much chance of coming out of this country as a great wine. Literature—yes, we know that we have done some great things in that line; the English and French have told us so. Now they can begin to tell us the same about our painting.

—Clement Greenberg

A painting that is an act is inseparable from the biography of the artist. The painting itself is a "moment" in the adulterated mixture of life—whether "moment" means the actual minutes taken up with spotting the canvas of the entire duration of a lucid drama conducted in sign language. The act-painting is of the same metaphysical substance as the artist's existence. The new painting has broken down every distinction between art and life

—Harold Rosenberg

At the Museum of Modern Art
by May Swenson

At the Museum of Modern Art you can sit in the lobby

on the foam-rubber couch; you can rest and smoke,

and view whatever the revolving doors express.

You don't have to go into the galleries at all.

In this arena the exhibits are free and have all

the surprises of art—besides something extra:

sensory restlessness, the play of attention,

expectation in an incessant spray

thrown from heads, hands, the tendons of ankles.

The shifts and strollings of feet

engender compositions on the shining tiles,

and glide together and pose gambits,

gestures of design, that scatter, rearrange,

trickle into lines, and turn clicking through a wicket

into rooms where caged colors blotch the walls.

You don't have to go to the movie downstairs

to sit on red plush in the snow and fog
of old-fashioned silence. You can see contemporary
Garbos and Chaplins go by right here.
And there's a mesmeric experimental film

constantly reflected on the flat side of the wide
steel-plate pillar opposite the crenellated window.
Non-objective taxis surging west, on Fifty-third,
liquefy in slippery yellows, dusky crimsons,

pearly mauves—an accelerated sunset, a roiled
surf, or cloud-curls undulating—their tubular ribbons
elongations of the coils of light itself
(engine of color) and motion (motor of form.)

Larry Rivers

Yitzroch Loiza Grossberg—Irving to the rest of the world—was born in the Bronx, New York, in 1923. In that peculiarly American metamorphosis, Irving Grossberg was born anew as Larry Rivers. In an Abstract Expressionist culture that venerated jazz, Rivers stood out as an actual, bona-fide jazz musician: a saxophonist who had studied composition at New York's prestigious Juilliard School of Music. (Miles Davis was a classmate.) The pot-smoking, hipster jazzman made quite a splash when coming to visit his parents' apartment building, a thoroughly Jewish enclave: "Larry was always coming home in this long overcoat with his strange haircut," his sister recounted, "saying a lot of things no one understood, telling weird jokes without a punchline, and using a lot of 'hey man, you dig, man, go, man...'"

The flamboyant Rivers sported attention-getting hand-painted ties and was an aficionado of motorcycles and foreign cars. He can be seen as Milo the railroad employee (in uniform) in the film *Pull My Daisy*, the iconic Beat-era classic made by Robert Frank and Jack Kerouac. Dispensing with any distinction between high culture and lowbrow mass culture, Rivers in 1958 was a contestant on *The $64,000 Challenge* TV quiz show, winning the not-untidy sum of $32,000. He had deep links to the poetry world and also designed sets for dramatic works based on the writings of Frank O'Hara, as well as Amiri Baraka. In 1966, tasked with designing the sets for Lincoln Center's production of Igor Stravinsky's *Oedipus*, Rivers managed to incorporate visual references to sports and boxing.

There were, unfortunately, issues of substance abuse, an Abstract Expressionist plague. During his life as a jazz musician, Rivers fell victim to the allure of heroin. As a painter, he undertook a series of nude studies of his aged mother-in-law (who possibly qualifies as one of the best sports in the history of modern painting) and gained lasting infamy at the funeral of poet Frank O'Hara with a eulogy that included an all-too graphic enumeration of O'Hara's fatal injuries. ("He was purple wherever his skin showed through the white hospital gown.... Every rib was cracked.")

Larry Rivers seems to have been an acquired taste. There were strong doses of irreverence and irony to his work, which was not exactly common in the AbEx world. Jacques-Louis David's classic, stately portrait *Napoleon in His Study* (1812) was revamped, Rivers-style, as *The Greatest Homosexual* (1964). He relentlessly incorporated detritus and the iconography of mass culture in a way that anticipated pop art. Anything was fodder for inclusion in his work: Camel cigarette cartons, the faces of John Kennedy and French president Charles de Gaulle, the menu of the Cedar Tavern. His honest-to-a-fault 1992 autobiography (with copious references to sex, drugs, and sex) is titled *What Did I Do?: The Unauthorized Autobiography*. (The subtitle takes a few seconds to penetrate.)

> **I accepted the call to make most of life seem absurd.**
>
> *–Larry Rivers*

For all of the strong Abstract Expressionist affirmation as an American art, there was not, as a rule, an abundance of everyday experience in its actual output. AbEx was not known for being especially topical. (Nor was it required to be especially topical, of course). Rivers was one of the few to reference day-to-day life in the United States, delivering a tongue-in-cheek

look at the American mythos: *Football Players* (1951), *Washington Crossing the Delaware* (1953), *Small Drugstore* (1959), and the like. Larry Rivers was Abstract Expressionism's resident American Studies professor. It was not all lampooning. *Second Avenue* (1958) is a stunning study in somber, expressive blue with traces of the cityscape, subtle and beautiful. There is a stark and somber inflection to much of Rivers's work. *Drugstore* (1959), with its quiet air of decrepitude, could be construed as the visual equivalent of a Richard Yates story.

Larry Rivers died in 2002. His reputation faded quite a bit, but the irony is that he was done in by his own artistic innovations. *Molly and Breakfast* (1956), for example, has a quasi-trippy feel to it, but when the 1960s exploded, quasi-trippy paintings from the 1950s weren't all that interesting any more. Rivers's offbeat, all-but-the-kitchen-sink eclecticism—along with his love of debunking—gave his work a tremendous impact on what followed. Much of his work, paradoxically, feels dated, which in an odd way is a testament to his success: He did it first, but was overshadowed by those who borrowed from him. In the decades that followed the 1950s, the influence of Larry Rivers was immense, carrying over not just to subsequent art movements, but to design and graphics as well.

Okay.
What Did I Do?

I married two women.

I became a father to five children.

I made 3,120 artworks, 250 videos.

I accepted the call to make most of life seem absurd.

I spoke Yiddish with my family and later relearned it....

I read Proust and Primo Levi and the other histories
that came my way....

I pinned my hopes on love....

I forgave all those who left me out of major exhibitions....

I begged for money in Paris, playing a straight soprano sax
with a cup and a sign that said, "Blinded in May '68" (the uprising).
I was so moved by myself that I had my assistant film me....

What did I do? Tell me.

—Larry Rivers

Abstract Expressionism basically fell out of favor as the 1960s got underway. Current movements in all spheres of the arts can become much less current very quickly. The ultra-cool rock 'n rollers of the 1950s looked completely outdated after the British Invasion of the 1960s. The situation wasn't quite as extreme with the Abstract Expressionist painters—they didn't become instantly arcane. But the stage shifted to Pop Art, to Jasper Johns, to Robert Rauschenberg, to Andy Warhol, artists in synch with a new era and new modes of art-making, music, film: new sensibilities all around. And they were new sensibilities that Abstract Expressionism couldn't address.

> **Current movements in all spheres of the arts can become much less current very quickly.**

Abstract Expressionism's boozed-up bravado and repellant misogyny began to be seen as less than excusable. Even worse—fatal for an art movement that prided itself on being new and iconoclastic—that boozed-up bravado began to be seen as unfashionable, a sort of meat-and-potatoes dissipation. The AbEx painters began to be seen less as outlaws and more as guys sitting around in the bar. The sexism was another matter, which began to be viewed as a toxic relic of the recent past. It was not just a question of simple insensitivity, but something even more pernicious: They had relegated female painters of the first rank—Frankenthaler, Krasner, Mitchell, Hartigan, and so many others—into a subservient position.

The Abstract Expressionist talent was not in question, but they began to be seen as they often were: drunk, quarrelling—sometimes brawling—male painters who devalued women in every way.

And there was that matter of being outdated. So, it turned out, Abstract Expressionism played a role in Cold War politics. The CIA would never in a million years even *think* to utilize Andy Warhol's artwork in its propaganda efforts.

But if Abstract Expressionism quickly stopped being the latest and greatest in the art word, nothing diminished its lasting artistic impact, which has been substantial. Abstract Expressionism yanked the center of the art world out of its historic European home and transplanted it to New York City. That, in and of itself, was enormous. All these decades later, New York *still* occupies that central perch. It was as if AbEx changed a fundamental law of nature—that great painting emanated from Europe.

Abstract Expressionism was the classic revolutionary upstart, a collection of painterly outcasts and oddballs. It spread out of its hardscrabble,

downtown confines and went on to conquer the art world. Whether future painters took from AbEx or rejected AbEx, it was the force to be reckoned with. Generations of art-school students have studied it, learned from it, or chosen to ignore it. But there was no denying its impact.

Abstract Expressionism also burst out of its purely painterly confines and permeated to the larger visual world. Design, graphics, comics, advertising—they all bore the imprint of Abstract Expressionism. Visually, its effects were ubiquitous.

The Abstract Expressionists can also be construed as the grandparents of the do-it-yourself ethos. By sheer, obstinate will and talent, they crafted their artwork, heedless

> **Abstract Expressionism yanked the center of the art world out of its historic European home and transplanted it to New York City.**

of the larger art establishment or the public. Most of them sacrificed their material well-being for the lonely quest of an artistic vision. That sounds like a cliché: the determined painter, struggling on. In this case, however, there is truth to the cliché. There was no guarantee, in those hand-to-mouth days, that recognition would ever come. Willem de Kooning was probably very aware that he might have been forced to purchase sign-painters' supplies for the rest of his life. So *you* could do it too. You could take your against-the-grain paintings or your oddball comics, your loud garage band, your unconventional poems, and stay with them. You could *say something*.

The irony is that Abstract Expressionism became iconic. The further irony is that *iconic* equals valuable property. In 2013 Barnett Newman's *Ornament VI* (1953) sold at auction for $43.8 million. That would have been unimaginable to a painter who made regular trips to the pawn shop. Cynicism can be

difficult to avoid. "Owning original work shows that you've got money," Yoram Kaniuk has written. "Instead of hanging ten thousand one-thousand dollar bills, it's cheaper to hang a Motherwell."

> **The irony is that Abstract Expressionism became iconic.**

The AbEx legacy gets increasingly complicated. The painters took their outsized personalities and passions and emerged from the fringes. That was a real act of affirmation, a victory for all creative people stifled by conformist American society. The double-edged sword is that these painters' renown also stemmed from their infamous, boozy ways. The flamboyant, doomed painter makes for wonderful dramatic images. The reality is much less appealing. Many died young; many were burdened by a variety of substance-abuse issues. Arshile Gorky and Mark Rothko committed suicide.

Abstract Expressionism also spawned the dubious achievement of giving us the art-world celebrity. And that celebrity could make its way to art dealers and gallerists as well. The high-flying art-world personalities Larry Gagosian and Mary Boone, for example, were not painters; they were dealers and gallerists. Before Abstract Expressionism, such a phenomenon—the art-world celebrity *non-painter*—did not even exist.

The Abstract Expressionist body of work is imbued with humor, irony, tragedy, dystopia, and social commentary. The pure, simple tragedy of war can be gauged in the works of Arshile Gorky, the psychological after-effects of grief studied in the paintings of Lee Krasner. Abstract Expressionism is a cultural and psychological treatise.

It really comes down to the most important criterion of all: Abstract Expressionist artwork is a compelling visual experience. The paintings are interesting; there's a lot going on. That's the most basic, baseline evaluation, far removed from theory and painterly intent. The color combinations—swirling or stripped down—are fascinating; the shapes and flatness are intriguing, and the viewer has much to consider. A person can read book after book on the genius of Charlie Parker, but if you don't really listen to "Now's the Time" or "Yardbird Suite," the books really don't amount to much. Reading Clement Greenberg or Harold Rosenberg will only take you so far. Art doesn't have to be mysterious or profound. Abstract Expressionism can be viewed and enjoyed without an orientation in theory or history.

Abstract Expressionism also spawned the dubious achievement of giving us the art-world celebrity.

These days, there are a host of resources that enable easy access to learning about Abstract Expressionism. There are a huge number of books on the various painters themselves. The Internet, more and more, has become an essential source in viewing and reading about the AbEx world, especially as museums and archives increasingly open up their resources online.

Ultimately, though, the Abstract Expressionist paintings should be seen up-close and personal. This obviously depends, of course, on geographic

proximity; it's not like there's an AbEx painting on every block. But if it's at all possible, make the trip. The paintings, by intent, were made to be *seen*, looked over, discussed, enjoyed, not enjoyed, and puzzled over. All in all, AbEx is surprisingly user-friendly. The painters are providing you, the viewer, with an open invitation.

What can a painter do? Barnett Newman queried all those years ago. There's only one answer: Look and see.

Art of This Century: a New York City gallery founded by heiress Peggy Guggenheim in the 1940s. Art of This Century showed and championed the new-style painters who became the Abstract Expressionists.

The Beats: The Beats were a loosely affiliated group of writers, poets, and musicians in the 1950s who produced very iconoclastic, against-the-grain art. With their distinctive modes of dress, slang, and lifestyle, the Beats made a huge impact in a homogenized, conformist United States. The Beats and Abstract Expressionists, not surprisingly, were often woven together.

bebop/bop: terminology used to describe the revolutionary jazz that emerged after World War II. Bebop and subsequent modern jazz had much in common with the Abstract Expressionists: the painters, particularly, were quite influenced by jazz, looking to the musicians as kindred artistic outcasts and creative revolutionaries. Postwar jazz notables—who go beyond strictly bebop—include Charlie Parker, Dizzy Gillespie, John Coltrane, Ornette Coleman, Charles Mingus, Thelonious Monk, and Miles Davis.

Cedar Tavern: The déclassé Greenwich Village bar that became the central hangout for the Abstract Expressionists in the 1950s. The Cedar Tavern assumed a legendary and infamous perch in Abstract Expressionist folklore.

the Club: As the Abstract Expressionists became a more solidified group, the painters took to meeting regularly in a downtown building that was dubbed, simply, the Club. It was a hugely significant step in the formation of this new artistic movement.

Color Field: An offshoot of Abstract Expressionism. Color Field took many of Abstract Expressionism's concepts—like the flatness of the canvas—and shifted the emphasis away from the dramatic and gestural and toward a more restrained approach, at times using thinner paint, as well as distinctive pouring and staining techniques. As the term connotes, color composition was a central plank.

flatness: The flatness of the canvas was one of the main planks in the Abstract Expressionist artistic credo. For centuries, painters had tried (artfully, to be sure) to fool the viewer into thinking they weren't simply looking at a piece of canvas covered in paint, utilizing perspective and illusionistic space. Abstract Expressionism went entirely in the opposite direction, calling attention to the canvass's flatness.

WPA: The Works Progress Administration was one of the pivotal New Deal programs implemented by the Franklin Roosevelt administration. It employed over 8 million people in a wide variety of jobs and provided one of the crucial life rafts during the Depression. A special component, the Federal Art Project, offered specific relief to painters—the nucleus of the Abstract Expressionists.

Anfam, David. *Abstract Expressionism*. London, UK: Thames & Hudson, 1990.

Arnason, H.H. *Robert Motherwell*. New York: Harry N. Abrams, 1977.

Ashton, Dore. *The New York School: A Cultural Reckoning*. New York: Viking Press, 1973.

Greenberg, Clement. *Art and Culture*. Boston: Beacon Press, 1961.

Herrera, Hayden. *Arshile Gorky: His Life and Work*. New York: Farrar, Straus and Giroux, 2003.

La Moy, William T., and Joseph P. McCaffrey, eds. *The Journals of Grace Hartigan, 1951–1955*. Syracuse, NY: Syracuse University Press, 2009.

Lippard, Lucy R. *Ad Reinhardt*. New York: Harry N. Abrams, 1981.

Livingston, Jane, ed. *The Paintings of Joan Mitchell*. New York: Whitney Museum of American Art, in association with University of California Press, 2002.

Naifeh, Steven, and Gregory White Smith. *Jackson Pollock: An American Saga*. New York: Clarkson N. Potter, 1989.

Perl, Jed, ed. *Art in America 1945–1970: Writings From the Age of Abstract Expressionism, Pop Art, and Minimalism*. New York: Library of America, 2014.

Schapiro, Meyer. *Modern Art: 19th & 20th Centuries*. New York: George Braziller, 1978.

Schjeldahl, Peter. *Let's See: Writings on Art from* The New Yorker. New York: Thames & Hudson, 2008.

Seldes, Lee. *The Legacy of Mark Rothko*. New York: Holt, Rinehart and Winston, 1974.

Storr, Robert. *Philip Guston*. New York: Abbeville Press, 1983.

Stevens, Mark, and Annalyn Swan. *de Kooning: An American Master*. New York: Alfred A. Knopf, 2004.

Tuchman, Maurice, ed. *New York School: The First Generation*. Greenwich, CT: New York Graphic Society, 1965.

Wetzsteon, Ross. *Republic of Dreams: Greenwich Village: The American Bohemia, 1910–1960*. New York: Simon & Schuster, 2002.

The 2000 biopic *Pollock* is a fascinating film for anyone with a basic interest in Abstract Expressionism. Directed by and starring Ed Harris as Jackson Pollock, the film features Marcia Gay Harden as Lee Krasner and Jeffrey Tambor as Clement Greenberg.

Dawn Powell's novels serve as chronicles of New York City and the Village during the classic period when Greenwich Village was known the world over as bohemia central. Her acerbic 1962 novel *The Golden Spur* is not a novel about painters per se, but the artists' world—in all its magnificent, petty grubbiness—is on full display.

What Did I Do? is Larry River's "unauthorized autobiography," co-written with Arnold Weinstein and published by HarperCollins in 1992. It's eye-opening and quite graphic. Among other things, it establishes his jazz bona fides (leading to comparisons to *Straight Life*, saxophonist Art Pepper's searing memoir of drugs and hard living).

Almost every Abstract Expressionist painter is renowned enough to have a following and cultural attention. Many of the painters have their very own foundations, which is an amazing legacy. These foundations—more importantly—provide an invaluable aid in getting to know the specific Abstract Expressionists and their work.

Willem de Kooning, not surprisingly, has a foundation dedicated to his life and work: www.dekooning.org

Helen Frankenthaler envisioned her foundation as geared toward outreach and education, with a wide variety of resources: www.frankenthalerfoundation.org

A source for information on **Arshile Gorky**: The Arshile Gorky Foundation— http://arshilegorkyfoundation.org

There is a **Joan Mitchell** foundation, as well as the more hands-on Joan Mitchell Center, aimed specifically toward working artists and located, interestingly, in New Orleans. The Joan Mitchell Foundation— http://joanmitchellfoundation.org

Robert Motherwell established the Dedalus Foundation, an extensive education and outreach endeavor dedicated to modern art in all its manifestations. The programs and thrust are very far-reaching and it is, in addition, the official source for all things Motherwell: http://dedalusfoundation.org/foundation

A wealth of information on **Barnett Newman** can be found at The Barnett Newman Foundation: www.barnettnewman.org

The source for all things Frank O'Hara: www.frankohara.org

Jackson Pollock and **Lee Krasner** did much of their eventual work away from New York's claustrophobic art world, moving to the beachy Hamptons on Long Island. Their home and studio there can now be visited and also serves as a study center— http://sb.cc.stonybrook.edu/pkhouse/index.shtml

The Pollock-Krasner Foundation is a pivotal arts organization that provides grants that aid painters in their work: www.pkf.org

Additional info on **Richard Pousette-Dart** can be gleaned from the Richard Pousette-Dart Estate— http://richardpousette-dart.com

For information on **Ad Reinhardt**, there's the Ad Reinhardt Foundation For Art as Art— http://adreinhardt.org/reinhardtfoundation

The **Larry Rivers** Foundation Web site is informative and as funny and breezy as one would expect (leading off with a nasty quote from Clement Greenberg): www.larryriversfoundation.org/home.html

A repository of knowledge on **Clyfford Still** can be found at the Denver museum dedicated to him and him alone: Clyfford Still Museum— https://clyffordstillmuseum.org

Where to See Abstract Expressionism

New York City's **Solomon R. Guggenheim Museum** (founded by Peggy's uncle)—with its distinctive, iconic building designed by Frank Lloyd Wright— is a prime venue to see Abstract Expressionist paintings: www.guggenheim. org. If one is ever lucky enough to visit Venice, Peggy Guggenheim's collection—located, fittingly, right on the Grand Canal—is open to the public: www.guggenheim-venice.it/inglese/museum/info.html

The **Metropolitan Museum of Art**—the same museum whose exclusivity inspired the Irascibles all those decades ago—has long since made peace with Abstract Expressionism and boasts an amazing collection: www.metmuseum.org

Not surprisingly, New York's **Museum of Modern Art** (or MoMA) is AbEx central: www.moma.org

The **Whitney Museum of American Art** in New York City—in an entirely new space that's generated a lot of attention—has a wonderful example of the AbEx output: http://whitney.org

The Abstract Expressionists painted and caroused in New York City, so it's not much of a surprise that's where so much of their work is available. Other parts of the country, though, shouldn't be discounted. In California, there's an impressive array at **The Museum of Contemporary Art, Los Angeles**: moca.org

In the middle of the country, there's the **Art Institute of Chicago**: www.artic.edu

And Houston, Texas is the locale of the invaluable **Menil Collection**: www.menil.org

Abstract Expressionism also can also be seen in temporary exhibits at museums and art venues all across the country. It may take a little investigative work—but the results are more than worth it.

Richard Klin is the author of *Something to Say* (Leapfrog, 2011), a series of profiles of various creative forces discussing the intersection of art and politics. His work has been featured on NPR's *All Things Considered* and has appeared in the *Brooklyn Rail*, the *Forward*, *Kindling Quarterly*, Akashic Books' "Thursdaze" series, *Chronogram*, *January*, and other publications. He lives in New York's Hudson Valley.

Lily Prince has exhibited widely both nationally and internationally and has been awarded numerous commissions. She has her B.F.A. from The Rhode Island School of Design and her M.F.A. from Bard College. She was granted a residency at the BAU Institute in Italy, 2013, and at New York's The New Museum in 2014. Recent solo shows were at Vassar College and The Naples Museum in Florida. Prince's work has appeared in the *New York Times*, *New York* magazine, *San Francisco Weekly*, and *Bloomsbury Review*, among many other publications. Her work was published in the book *Something to Say: Thoughts on Art and Politics in America* (Leapfrog, 2011), by Richard Klin. Prince has lectured widely and is an Associate Professor of Art at William Paterson University. Her website is www.lilyprince.com.

African History For Beginners	ISBN 978-1-934389-18-8
Anarchism For Beginners	ISBN 978-1-934389-32-4
Arabs & Israel For Beginners	ISBN 978-1-934389-16-4
Art Theory For Beginners	ISBN 978-1-934389-47-8
Astronomy For Beginners	ISBN 978-1-934389-25-6
Ayn Rand For Beginners	ISBN 978-1-934389-37-9
Barack Obama For Beginners, An Essential Guide	ISBN 978-1-934389-44-7
Ben Franklin For Beginners	ISBN 978-1-934389-48-5
Black History For Beginners	ISBN 978-1-934389-19-5
The Black Holocaust For Beginners	ISBN 978-1-934389-03-4
Black Panthers For Beginners	ISBN 978-1-939994-39-4
Black Women For Beginners	ISBN 978-1-934389-20-1
Buddha For Beginners	ISBN 978-1-939994-33-2
Bukowski For Beginners	ISBN 978-1-939994-37-0
Chomsky For Beginners	ISBN 978-1-934389-17-1
Civil Rights For Beginners	ISBN 978-1-934389-89-8
Climate Change For Beginners	ISBN 978-1-939994-43-1
Dada & Surrealism For Beginners	ISBN 978-1-934389-00-3
Dante For Beginners	ISBN 978-1-934389-67-6
Deconstruction For Beginners	ISBN 978-1-934389-26-3
Democracy For Beginners	ISBN 978-1-934389-36-2
Derrida For Beginners	ISBN 978-1-934389-11-9
Eastern Philosophy For Beginners	ISBN 978-1-934389-07-2
Existentialism For Beginners	ISBN 978-1-934389-21-8
Fanon For Beginners	ISBN 978-1-934389-87-4
FDR And The New Deal For Beginners	ISBN 978-1-934389-50-8
Foucault For Beginners	ISBN 978-1-934389-12-6
French Revolutions For Beginners	ISBN 978-1-934389-91-1
Gender & Sexuality For Beginners	ISBN 978-1-934389-69-0
Greek Mythology For Beginners	ISBN 978-1-934389-83-6
Heidegger For Beginners	ISBN 978-1-934389-13-3
The History Of Classical Music For Beginners	ISBN 978-1-939994-26-4
The History Of Opera For Beginners	ISBN 978-1-934389-79-9
Islam For Beginners	ISBN 978-1-934389-01-0
Jane Austen For Beginners	ISBN 978-1-934389-61-4
Jung For Beginners	ISBN 978-1-934389-76-8
Kierkegaard For Beginners	ISBN 978-1-934389-14-0
Lacan For Beginners	ISBN 978-1-934389-39-3
Libertarianism For Beginners	ISBN 978-1-939994-66-0
Lincoln For Beginners	ISBN 978-1-934389-85-0
Linguistics For Beginners	ISBN 978-1-934389-28-7
Malcolm X For Beginners	ISBN 978-1-934389-04-1
Marx's Das Kapital For Beginners	ISBN 978-1-934389-59-1
Mcluhan For Beginners	ISBN 978-1-934389-75-1
Mormonism For Beginners	ISBN 978-1-939994-52-3
Music Theory For Beginners	ISBN 978-1-939994-46-2
Nietzsche For Beginners	ISBN 978-1-934389-05-8
Paul Robeson For Beginners	ISBN 978-1-934389-81-2
Philosophy For Beginners	ISBN 978-1-934389-02-7
Plato For Beginners	ISBN 978-1-934389-08-9
Poetry For Beginners	ISBN 978-1-934389-46-1
Postmodernism For Beginners	ISBN 978-1-934389-09-6
Prison Industrial Complex For Beginners	ISBN 978-1-939994-53-0
Proust For Beginners	ISBN 978-1-939994-44-8
Relativity & Quantum Physics For Beginners	ISBN 978-1-934389-42-3
Sartre For Beginners	ISBN 978-1-934389-15-7
Saussure For Beginners	ISBN 978-1-939994-41-7
Shakespeare For Beginners	ISBN 978-1-934389-29-4
Stanislavski For Beginners	ISBN 978-1-939994-35-6
Structuralism & Poststructuralism For Beginners	ISBN 978-1-934389-10-2
Women's History For Beginners	ISBN 978-1-934389-60-7
Unions For Beginners	ISBN 978-1-934389-77-5
U.S. Constitution For Beginners	ISBN 978-1-934389-62-1
Zen For Beginners	ISBN 978-1-934389-06-5
Zinn For Beginners	ISBN 978-1-934389-40-9